W9-BPK-731

WATERCOLORS
STILL LIFE

Brian and Ursula Bagnall • Astrid Hille

WALTER FOSTER PUBLISHING, INC.

Laguna Hills, California

Published by Walter Foster Publishing, Inc.,
23062 La Cadena Drive, Laguna Hills, CA 92653.
All rights reserved.

English translation copyright © 1996 Joshua Morris
Publishing, Inc., 355 Riverside Avenue, Westport, CT 06880.
Produced by Joshua Morris Publishing, Inc.
© 1992 by Ravensburger Buchverlag
Otto Maier GmbH, Ravensburg.
Original German title: *Aquarell—Stilleben laut und leise.*
Cover painting by Brian Bagnall.
Printed in Hong Kong.

ISBN: 1-56010-182-2
10 9 8 7 6 5 4 3 2 1

Contents

About This Book

Watercolor is one of the most popular painting media ever. One of the advantages of watercolor is that it is convenient for traveling; the paint and paper are easy to carry, and water can be found almost anywhere. Additionally, watercolor permits spontaneity; it allows the artist to turn a few brush strokes into a painting, and the resulting runs in the paint can often produce some interesting effects. This spontaneity, however, can also pose problems for the beginning watercolorist. How do you avoid these effects—or intentionally produce them? In short, how do you handle a medium that often seems to have a mind of its own?

This is precisely where this book will help you. It isn't that difficult to paint a wild sky or a fantastic landscape, but how do you give the impression that an apple is sitting firmly on a surface? How do you make it seem as if the cloth you're painting is actually draped across a table or that you can reach out and touch the vase in your picture?

We'll take a look at all kinds of still lifes, both traditional setups as well as more unusual ones. You'll learn how to transfer objects onto paper and arrange them in interesting compositions, how to exaggerate or reduce their sizes, and how to emphasize the important aspects and eliminate the unimportant ones. Four different artists will demonstrate their personal styles and approaches for painting in watercolor, and you'll be able to follow along, step by step.

You'll learn to experiment and to use your imagination. Tips, tricks, and a wide selection of motifs will help you to develop your own personal painting style.

Have fun!

Ursula Bagnall

Ursula Bagnall is the partner of Brian Bagnall—art director for the Artist's Workshop series—and she is responsible for text and layout. She brings the artists' outlooks, explanations, and paintings together and creates a useful and easy-to-use learning tool.

Ursula was born in 1945 and completed her training in graphic design at the Akademie für Graphisches Gewerbe in Munich. Afterward, she worked with Otl Aicher for the 1972 Olympics and later took a five-year teaching position at an American school in Amsterdam. In addition to freelance work for the Bavarian television station in Germany, she has worked since 1973 as a freelance graphic artist and author. She and her husband have written many books together, among them several art instruction books for children and adults.

Astrid Hille

Astrid Hille is the editor of the Artist's Workshop series and works closely with Bagnall Studios. She was born in 1955 in Hamburg, Germany, where she completed training as a technical illustrator at the Fachhochschule für Kunst und Gestaltung. She later went on to study illustration and painting. After her studies, she worked as an illustrator, painter, and art teacher in adult education. She completed a second degree in multimedia education and has been a proofreader of art books and children's books since 1985.

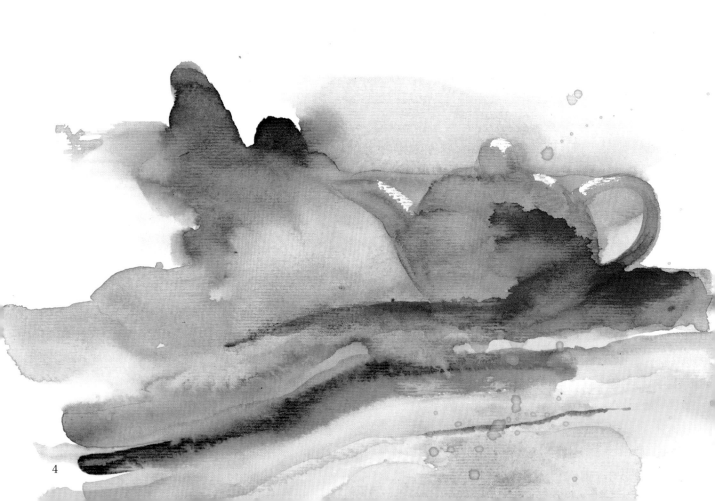

Brian Bagnall

Brian Bagnall will show you how to create a still life using found objects.

Brian was born in 1943 in Wakefield, England. He studied painting and etching and completed his National Diploma with honors. He then moved to Amsterdam where, in addition to teaching, he worked for numerous publishing houses and advertising agencies.

Since 1970 he has lived in Munich, where he and his wife opened Bagnall Studios. Brian was also active for many years as a professor in Darmstadt, Germany. He has written a number of books, and his work has been exhibited all over Europe and Korea.

Jos K. Biersack

Jos K. Biersack will demonstrate how to paint a transient motif containing both fresh and wilted flowers.

Jos was born in Oberpfalz, Germany, in 1941. He studied interior design in Nuremberg, Germany—a career he pursued until 1990. He began watercolor painting as a hobby. In 1981 he was discovered by a gallery owner and was soon having his first exhibit. He also mastered the art of etching under the tutelage of Karl Stengel, and his free time was soon filled with painting. More exhibits followed in Austria and Italy. He gave up interior design once and for all in 1990 and is now a full-time artist.

Eberhard Lorenz

Eberhard Lorenz will show you how to paint a classical still life of fruit and folds of flowing fabric.

Eberhard was born in the German state of Saxony in 1936 and studied art in Leipzig, Germany, from 1953 to 1956. Afterward, he worked as a set designer for a West German broadcasting system and as a stage designer in Munich's Theater am Gärtnerplatz. In 1967, he started teaching painting and graphic design. Mr. Lorenz currently works as a freelance painter in Oberschleissheim and has made quite a name for himself in single and group exhibitions all over Europe.

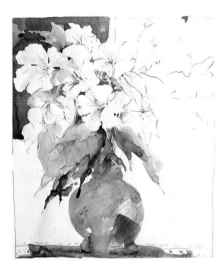

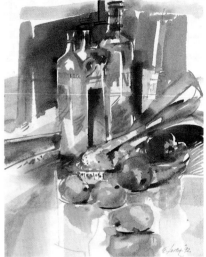

Karlheinz Gross

Karlheinz Gross will share an interesting still life he discovered while polishing his shoes.

Karlheinz was born in 1943 in Harz, Germany, and studied at the Werkkunstschule A.L. Merz in Stuttgart. He later took courses in commercial art and illustration under Professor Robert Förch at the Gutenbergschule, also in Stuttgart. In 1966 he opened his own studio in Bietigheim-Bissingen, Germany, and has since worked as a freelance graphic artist and painter. He also teaches watercolor painting. He paints his colorful and expressive paintings during his many travels and excursions. Since 1971, his work has appeared in numerous single exhibitions.

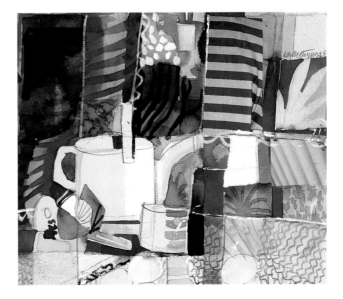

Watercolor—Yesterday and Today

Painting with water-soluble paints is one of the oldest methods of recording events. All painting from the dawn of culture to the discovery of oil paints and oil tempera was done in water-based media—albeit not in the sense of the watercolor paints with which we are familiar today. Prior to the ninth century, most Greek and Roman miniatures were coated with an opaque mixture of water-based paint and cerrusite. After the ninth century, artists began to paint in transparent watercolors as well. This development continued through the Middle Ages, and the practice of painting miniatures with watercolor was widespread by the time of the Renaissance.

Albrecht Dürer (1471–1528) left behind some breathtaking watercolor paintings, though they are not as well-known as his drawings, etchings, and oil paintings. At that time, watercolor painting was not viewed with the same respect as oil painting.

Watercolor was used purely in a documentary fashion (nature studies) or to sketch ideas for subsequent oil paintings.

It was not until the nineteenth century that watercolor was truly established as an art in its own right. The first watercolorist society was founded in England in 1804, and the first watercolor exhibit was held in 1805.

The most famous English watercolor artist is J.M.W. Turner (1775-1851).

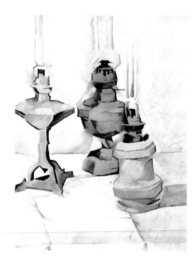

Juan Gris, *Three Lamps*

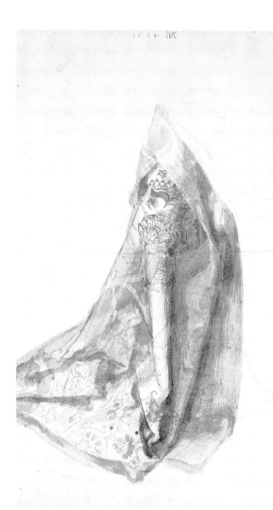

Albrecht Dürer, Study for Pope's Robe for *The Feast of the Rose Garlands*

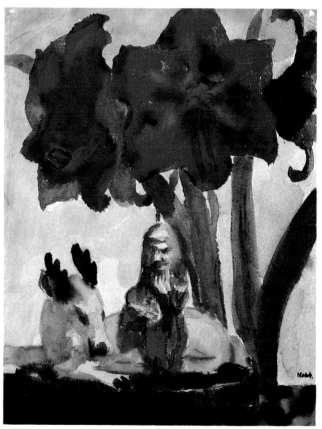

Emil Nolde, *China Figurine and Amaryllis*

During his trips to Italy, he created watercolor paintings with intense light and color effects and achieved an extraordinarily high level of skill in this medium. He inspired French Impressionists such as Edouard Manet.

Paul Cézanne (1839–1936) used watercolor to skillfully incorporate the properties of the medium—transparency and brilliance—into his paintings and to create a synthesis of shape and color.

At the beginning of the twentieth century, the Spanish painter Juan Gris (1887–1927) experimented with the expressive qualities of color in his watercolor studies. These early works hint at his later fascination with Cubism.

The German Expressionist Emil Nolde (1867–1956) loved nature and primitive art. His watercolors are especially brilliant and expressive, and he took particular advantage of the paint runs.

Landscapes constitute the classic watercolor motif, but artists of all epochs have painted still lifes in watercolor. Prior to the sixteenth century, still life was not considered an independent motif; instead, the objects usually had some symbolic significance or were used as decorative elements in the larger composition. Since the seventeenth century, however, artists have focused on the still life as a motif in its own right.

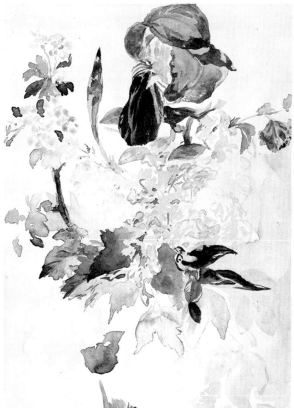

Edouard Manet,
Flower Piece with
Laburnum and Irises

Paul Cézanne,
Still LIfe with Chair, Bottles, Apples

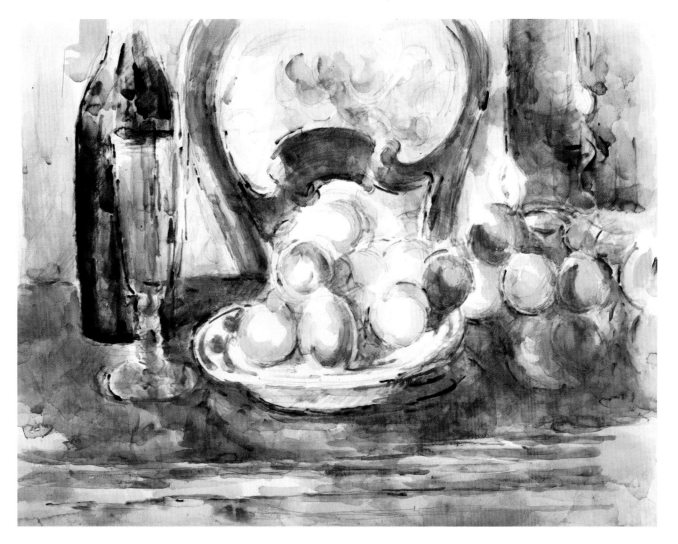

Choosing Materials

Good materials are essential for a successful watercolor painting. You don't have to buy a lot of brushes and paints, but make sure the ones you do buy are of high quality.

Selecting Paints

Watercolor paints come in tubes and in pans, and both types are available individually or in sets. The sets are convenient because you can store your brushes inside the box and use the lid as a palette. The disadvantage is that they often contain colors that don't intermix well. Thus, make sure you have the following basic colors:

chrome yellow, cadmium yellow light, cadmium red light, alizarin crimson, cerulean blue and ultramarine blue (more about this on pages 11 and 12).

You'll have to experiment to decide whether you're more comfortable with tubes or pans. The tube paints are more brilliant and can be applied in a more concentrated form. If they dry on the palette, you can simply add water and reuse them. You have to add water to pan paints each time you use them, which makes them difficult to apply in thick coats.

It is important to leave space between the individual pans in the paint box, otherwise the paints will run together.

In addition to regular watercolors, you can also use colored inks to create some interesting effects.

Selecting Brushes

As suggested above, buy fewer brushes of higher quality. Genuine sable brushes (sometimes called red sable or kolinsky sable) are a good choice. If you paint pictures of average size, one thick brush (a number 10) and two thinner ones (a number 3 and a number 6) will suffice. You can also buy several inexpensive brushes to paint backgrounds or to work out

rough areas of your paintings. When you're not using your brushes, roll them up in a bamboo mat to protect them from dust and to prevent the delicate tips from getting bent. If you don't plan to work with your brushes for a while, store them in a drawer or a closed container to prevent dust from building up in the tips and causing them to fray. You should always clean your brushes thoroughly with mild soap after each use. Shake them (don't squeeze!), and allow them to air dry.

Odds and Ends

You'll need a water container, a towel to blot up excess paint, and a small sponge to create textures. A metal palette, a plastic palette, or a disposable paper palette made of individual sheets of water-repellent paper (see picture below, lower left) work well for a mixing surface. A brush holder that allows excess paint and water to drip off is helpful and practical but not absolutely necessary. (Never set your brushes tip-down in water.)

Use a soft pencil for sketching. Try to avoid erasing, however, because it can damage the paper, resulting in rough, ugly areas when you paint over it. You can use liquid frisket or rubber cement for retaining white areas. If you work on individual sheets of paper, you'll also need a sturdy board for stretching the wet paper.

Selecting Paper

Paint behaves differently on different kinds of paper, so the texture of the paper influences the way you paint. You can see this clearly in the example at the right. The paint is absorbed uniformly on the smooth paper, but white areas remain on the rough paper. Buy samples of different kinds of watercolor paper, and experiment to see which effects you like most and which type of paper you prefer.

Watercolor paper is available in blocks or in individual sheets. Since the paper buckles when it gets wet, you have to stretch the single sheets on a board and tape down the edges. The blocks are bound along all four edges to prevent the paper from curling up as you paint. Many artists prefer the individual sheets because the selection of papers is larger, but, if you like to paint outdoors, the blocks are much more practical.

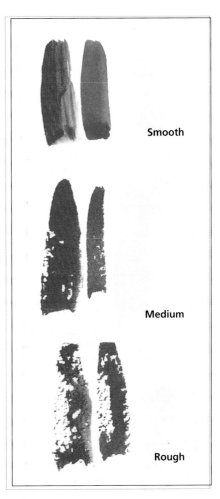

Smooth

Medium

Rough

Mixing Paints

There are two ways to mix paints: on the palette before you begin painting or directly on the paper while you're painting. Watercolorists typically use a combination of the two techniques. When mixing colors and allowing them to run together on the paper, it is particularly important to know which ones mix together well and which ones don't.

If you mix the wrong colors, it's easy to end up with ugly browns. It's wise to take this into account when you're buying paints. It's best to buy fewer colors, and make sure those you do buy intermix well. The following colors are sufficient for a basic palette: cadmium yellow light, cadmium red light, cerulean blue, chrome yellow, alizarin crimson, and ultramarine blue. The example below illustrates the results you can get by mixing these colors.

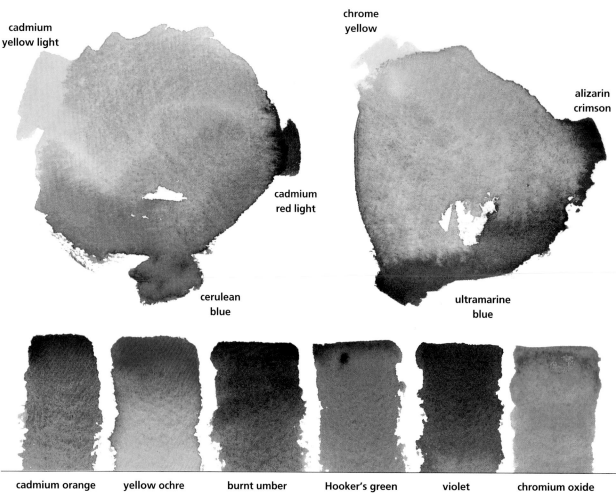

cadmium yellow light

chrome yellow

alizarin crimson

cadmium red light

cerulean blue

ultramarine blue

| cadmium orange deep | yellow ochre | burnt umber | Hooker's green | violet | chromium oxide green |

If you want to expand your palette beyond the basic colors, the colors shown above can offer you extensive possibilities. Grays are particularly useful. A number of "ready-made" grays are available; however, you can get much more colorful grays by mixing them yourself, using three different colors (see circles on page 11) or using Payne's gray.

At the right are three examples (from left to right): Payne's gray mixed with cadmium yellow, with cadmium red, and with cerulean blue.

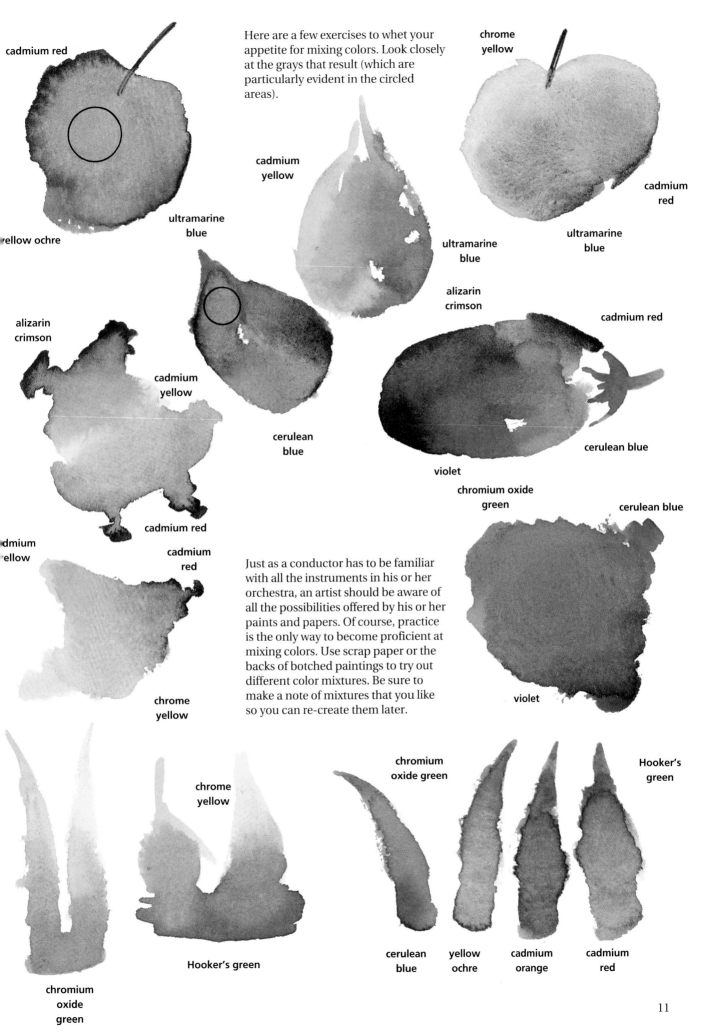

cadmium red

yellow ochre

Here are a few exercises to whet your appetite for mixing colors. Look closely at the grays that result (which are particularly evident in the circled areas).

chrome yellow

cadmium red

ultramarine blue

cadmium yellow

ultramarine blue

ultramarine blue

alizarin crimson

alizarin crimson

cadmium red

cadmium yellow

cerulean blue

cerulean blue

violet

cadmium yellow

cadmium red

Just as a conductor has to be familiar with all the instruments in his or her orchestra, an artist should be aware of all the possibilities offered by his or her paints and papers. Of course, practice is the only way to become proficient at mixing colors. Use scrap paper or the backs of botched paintings to try out different color mixtures. Be sure to make a note of mixtures that you like so you can re-create them later.

chromium oxide green

cerulean blue

violet

chrome yellow

chromium oxide green

Hooker's green

chrome yellow

Hooker's green

chromium oxide green

cerulean blue

yellow ochre

cadmium orange

cadmium red

Various Techniques

One of the most appealing aspects of watercolor is the spontaneity with which the paint can be applied. Despite this, however, there are a few techniques watercolorists should master in order to intentionally cause these "spontaneous" effects.

Working Wet-in-Wet

In this technique, the paper is dampened with a brush or sponge, and the paint is applied to the wet surface, causing the edges to run and "bleed." (Note: wet-in-wet technique is unsuitable for painting sharp edges and straight lines.) If you apply several different colors, they will run into one another and create new hues. You have to be careful that "puddles" don't form on the paper, since this results in ugly dark areas after the paint dries.

If you want to use this technique only for specific parts of the painting, you can wet just those portions of the paper. This method is illustrated clearly in the apple on page 13.

Applying Glazes

Glazing involves applying a thin layer, or glaze, of paint over another layer of paint, allowing the first color to shimmer through. Watercolor lends itself extremely well to this technique because the paints are so transparent. Glazing makes it possible to consciously create certain effects and interesting color nuances, such as those in the pattern shown below.

In order to do this, you have to let the first color dry completely before you apply the glaze. You should apply the top layer carefully and work relatively quickly, otherwise the bottom layer will begin to dissolve.

Working Wet-on-Dry

As you might guess from the name, this technique involves applying wet paint to a dry surface, either to blank paper or to dry layers of paint. This way, the paint won't run; instead, you can create distinct edges (see the outside edges of the leaf and the apple in the example on page 13).

Since the brush strokes frequently resemble lines, particularly if you paint on a dry background, you should practice your brush technique. Experiment with the brush: vary the amount of pressure you apply, rotate the brush, use just the tip and then the whole brush. You'll be surprised at all the different strokes you can create using just one brush.

Using White in Watercolor

In general, watercolorists do not use opaque white paint. Therefore, it is a good idea to plan out the white areas of your picture carefully before you begin to paint, and leave those areas of the paper blank. The soda can and the highlights on the apple are good examples of this technique. As you can see, it's all right to have pencil marks visible through the paint. Just be careful if you decide to erase

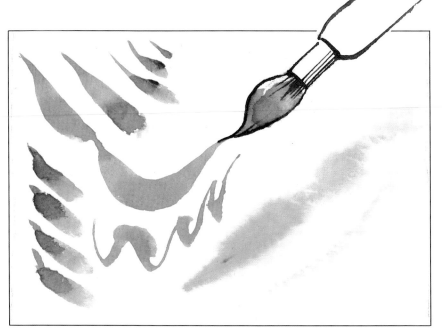

An experiment with brushes: The blue strokes were painted on a dry surface, the green ones on a wet surface.

them—it's easy to remove paint in the process. Of course, it takes a little practice to prevent dark lines from forming where the paint meets the blank paper.

Another way to keep an area white is to first coat the area with a masking solution, such as rubber cement or liquid frisket, and then paint over it. After the paint has dried, carefully rub off the solution and the white areas will be exposed. If you leave the solution on the paper, small drops of paint will remain on top of it, which can also be very interesting. This technique was used for the apple leaf.

Laying Washes

The best way to create smooth areas of color in your painting, such as for a background, is to lay in a flat wash. Apply the paint to damp paper, working from top to bottom and using a wet brush and quick, overlapping strokes. For a graded wash, begin with paint that is relatively thick, and add water as you go, creating a gradually lighter hue as the paint thins.

The white areas on the can are used as a stylistic element, as are the pencil lines. Remember, anything goes, as long you like it.

Above are some examples of washes on cold-pressed watercolor paper. In both cases, the paint was applied from dark to light. The paper was turned upside down for the blue wash.

The surface of the apple was applied wet-in-wet. The highlights were left white.

13

Creating Moods

Even without a motif, a color composition can be very expressive. Colors by themselves can appear happy or sad, boring or exciting. Let's begin with the difference between warm and cool colors. Generally, reds appear warm and blues appear cool, and we associate these colors with things that have to do with warmth and coolness. For example, we associate red with fire and the sun; we associate blue with water and ice. Despite these associations, it is possible to have cool reds and warm blues—it all depends on the amount of blue or red in a particular color. A blue that contains a large amount of red will have a warmer effect, and a red with a large amount of blue will have a cooler effect. Of course, there are also neutral colors that are not so easy to categorize, such as yellow-green and red-violet.

Look at the examples to the right. Despite the blue background, the apple and the cherries in the top picture exude happiness and warmth because the reds and yellows dominate the composition. On the other hand, the apple in the bottom example appears gloomy and cold—the blues are more prominent here.

Compare the white areas in the cherries in both paintings. The same type of paper was used in both cases, but the whites appear yellow in the "warm" picture, while they underscore the impression of coolness and have a blue effect in the other picture.

In general, cadmium hues are warmer than alizarin-based mixtures.

cerulean blue

cadmium yellow

cadmium red

Hooker's green

ultramarine blue

alizarin crimson

lemon yellow

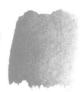
chromium oxide green

The color scheme also influences the mood of a painting. Dull, opaque colors are associated with sadness; bright colors give the impression of happiness; monochrome compositions appear calm; sharp contrasts seem aggressive.

You can see clearly how colors affect mood in this example. The upright flower looks alive, the bent flower seems to be wilting, and the apple no longer looks quite fresh. The color scheme here determines the impression of freshness more so than the motif itself. (A bent flower doesn't necessarily have to be wilted; this impression comes entirely from the colors.)

The areas that have been left white reinforce the overall impression—the highlights make the glass seem transparent, and the dark shadows at the bottom provide depth and contrast.

As an exercise, make a few color sketches while attempting to create particular moods without a concrete motif. Show your picture to a friend to see what kind of effect the colors have on someone else.

Modeling Textures

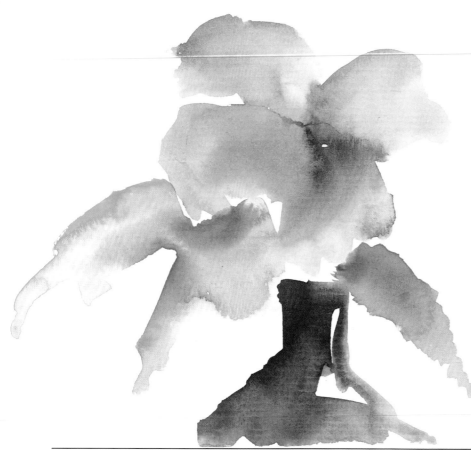

When painting still lifes, the various textures of the objects you are painting play an important role. Wool has an entirely different texture than silk; wood is rougher than glass; and an apple is shinier than a peach. It isn't easy to depict these various textures using watercolor.

The flowing quality of the wet-in-wet technique lends itself to painting soft textures. In the flower to the left, you can see that the gentle runs help give the impression of a delicate flower with soft leaves.

The glass below is entirely different. The wet-on-dry technique was used here—that is, the paint was applied on a dry background. If you want to paint a glass, first observe the highlights and determine which ones are important for the shape. In this example, the white areas were first masked with liquid frisket, which was then rubbed off after the paint had dried.

The delicate folds in the cloth below were achieved using the glazing technique. The lines, which were drawn using a flat brush, create the "narrowing" effect in the folds. The shadows were painted in after the paint had dried, giving the cloth more plasticity or form.

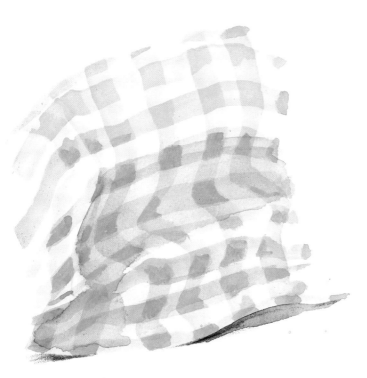

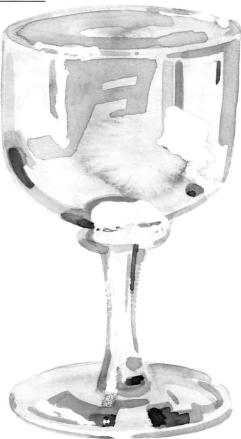

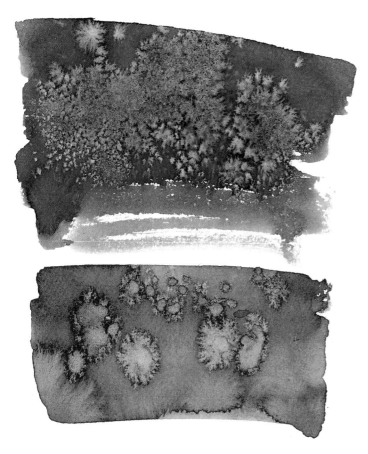

A Few More Tricks

If you paint with saltwater (at the ocean, for example), the salt crystals cause the paint to recede and dry around the edges. This technique results in interesting textures. In the example to the left, the artist wasn't able to paint at the ocean, so the paint was applied first, and then salt was sprinkled onto the wet paint. Fine salt was used in the top example and coarse salt in the bottom example. Try it yourself. (By the way, you can also get some unusual results by using citric acid.)

Below a wax crayon was used to give the lemon its rough peel. (You could also use a candle.) Since the paint doesn't stick to the "waxed" areas, they remain white. If you use colored wax crayons, the color of the crayon shows through. The cross-hatching below the lemon, which helps accentuate the shadows, was drawn in using pen and black ink. The pear at the bottom right was created by drawing into wet paint with a pen.

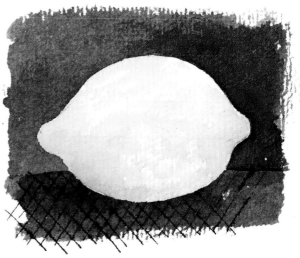

Wet spatters in wet paint flow into soft shapes. This is how the pear below was created. Then a small sponge was dipped into the green and lightly dabbed on the dry areas. As you can see, you don't always have to use a brush with watercolor.

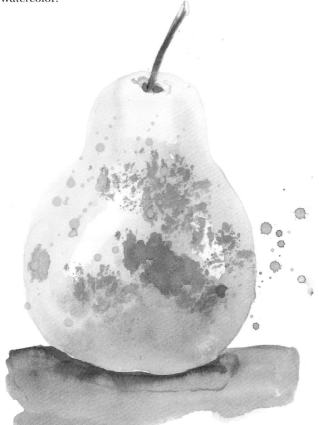

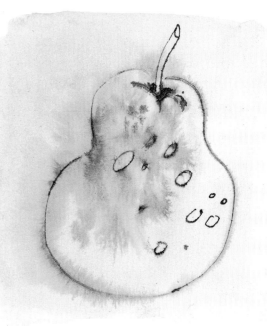

17

Applying the Techniques

Not every painting has to be a masterpiece. Even practice sketches can have a certain charm.

In this example, the techniques discussed thus far were used to paint a simple still life. Try something similar yourself. Don't worry about creating a perfect representation; instead, concentrate on experimenting with all the different possibilities watercolor has to offer.

Wet-on-Dry

The handle was painted with yellow and yellow ochre first, and then orange was used to create the edge. Fine brush strokes are essential for creating distinct contours and clear drawings. Moreover, the background has to be completely dry. Then you can draw on top of it with slightly thinned paint.

Border Lines

If you let one color dry and then apply another color next to it, hard edges result (above). This is a good way to make border lines, such as the edge of a table.

Wet-in-Wet

Large areas of foreground and background are best applied using the wet-in-wet technique. The relatively precise elements in the painting contrast with the paint runs, which adds excitement.

Liquid Frisket

The white highlights on the fruit and the teapot were created using liquid frisket. First, the area was masked, then painted over. After the paint had dried, some of the frisket was rubbed off. Liquid frisket comes in a tube, which can be used like a pencil to draw directly on the paper.

Colors used:

burnt umber
yellow ochre
cadmium orange light
cadmium yellow
alizarin crimson
chromium oxide green
violet
cerulean blue

Brush: *red sable number 6*

Paper: *rough watercolor paper*

Learning to See

So far, you've learned about colors—their effects and how to use them to create moods and expressive compositions. Now comes the tough part: depicting objects convincingly.

How do you make a three-dimensional object appear that way on paper? How do you make it look as if it's standing solidly on a surface? How do you make certain that a large plant and a small apple are in the proper proportions on the page?

Keen observation is most important. Too often, we simply give the motif a cursory glance and then rely on our experiences and seeing habits to finish it on paper. When sketching and drawing, however, this practice is more of a hindrance than a help. It is essential to get to the essence of an object in order to represent it on paper.

This may sound difficult, but there is one simple technique you can use to help you: breaking down objects into basic shapes. In general, most things can be broken down into five basic shapes: the square, the triangle, the circle, the rectangle, and the oval. Look around. These shapes are almost everywhere. The clock is round, the table is rectangular, and the coffee pot is triangular. Try to find these shapes in your surroundings. Below is a sketch of a few objects with basic shapes you can identify. The oval results from the way in which perspective causes the circle to recede into the background. The body of the bottle contains a rectangle.

For practice: Lay a piece of tracing paper on top of this sketch and trace all the basic shapes you can find.

20

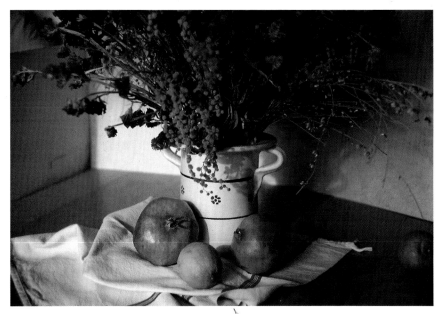

A bouquet of dried flowers in a ceramic vase, pomegranates, and a cloth—a simple, classical still life.

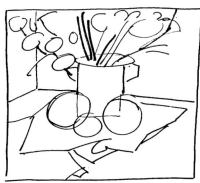

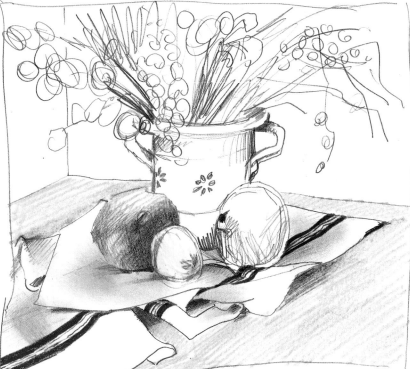

First the objects have to be simplified and sketched out. Even though the flowers seem somewhat complicated, they can be broken down into basic shapes. All of the other elements in the picture are reduced to shapes and lightly sketched on paper. Then you can work with shadows, colors, and patterns.

You can also alter the view. Feel free to leave out parts that you don't like. To the right you can see that the picture becomes more interesting when the view is narrowed; the motif is emphasized (more about this on pages 24 and 25).

After you select the motif, break it down into basic shapes. Then you can add details and determine the view.

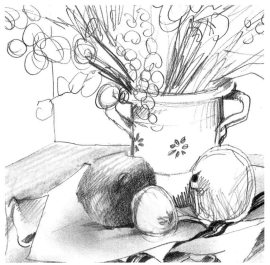

21

Positive and Negative Space

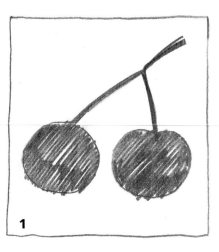

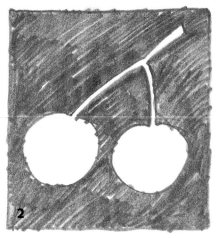

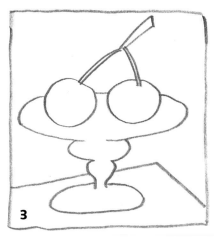

When we look at something, we usually see only the shape of the object—not the space that surrounds it. But this space—the negative space—actually gives the object its shape and is very important for the composition. Above is a simple example. Figure 1 represents the way we look at things; we see two cherries. Out of habit, you'll probably see two cherries in Figure 2 as well, although they look like a hole in the black background. If you look more closely, however, you can see that the background actually has a shape of its own.

The border of a picture created by a frame or any sort of line defines an object's surroundings and emphasizes the negative space. If you look at Figure 3, you probably see a bowl of cherries at first, but, if you ignore the motif and look only at the lines, you can discover many different shapes. It's up to the artist to decide which shapes are most important for the composition.

Figure 4 is a classic example: The motif is the main element, and everything else recedes into the background. On the other hand, you may want the table to be the most important element, as in Figure 5. Notice that in Figure 6, the background also has a very interesting shape. Finally, in Figure 7, the background is emphasized, and it is the most important element.

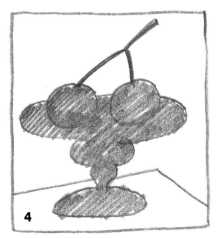

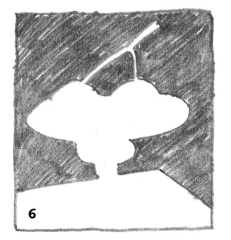

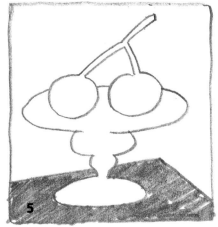

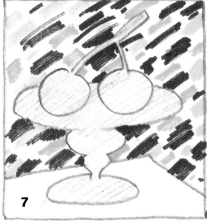

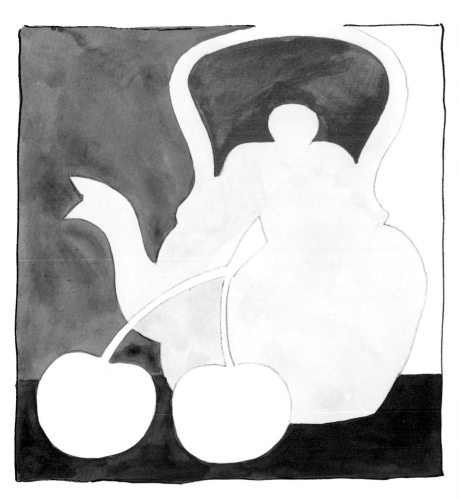

Looking at negative space takes some getting used to, but it has to be planned just as carefully as the positive space. In the examples shown here, you can see two possibilities for experimenting with positive and negative space. For the sake of simplicity, a basic composition with distinct shapes was chosen. The expressive quality of the colors—for example, whether they are warm or cool—is unimportant.

The bright shape of the teapot juts into the foreground, but it is actually the red area below the handle that dominates the composition. The cherries are secondary, and their role in the composition is similar to that of the white area in the background.

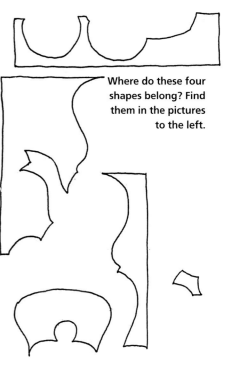

Where do these four shapes belong? Find them in the pictures to the left.

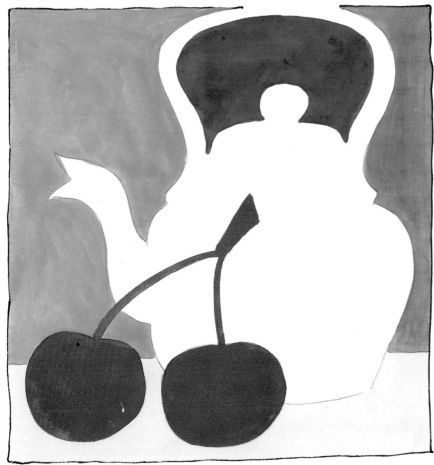

In this example, the teapot looks like a white hole in the picture. The cherries and the colorful areas in the background are the most important elements now.

Here's a good exercise: Look at some pictures—either photographs or your own drawings—and try to break them down into areas without paying attention to the motif. The easiest way to do this is to use a piece of tracing paper and trace the areas with a soft pencil. You'll quickly realize the importance of negative space and how it is used to support the positive space.

Composition

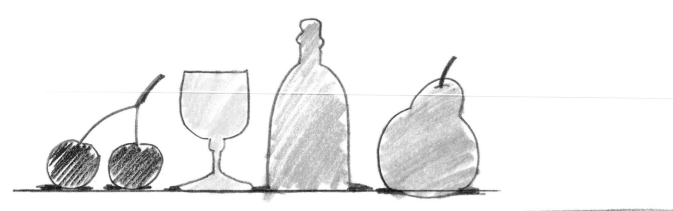

The distribution of shapes is not the only concern in painting. Depth also plays an important role (as long as you're not painting an abstract motif). Some parts of the picture should appear closer than others. Perhaps you feel a small cherry is more important than a large bottle. In this case, the cherry should be nearer in the foreground. If you look at the individual objects shown above, you can see that none of them is any more important than the others—all four are equal.

By simply changing the positions of the individual objects, as in the example to the right, the relationships between the objects change. Now the pear is closer to the observer than the bottle, and the glass is closer than the cherries.

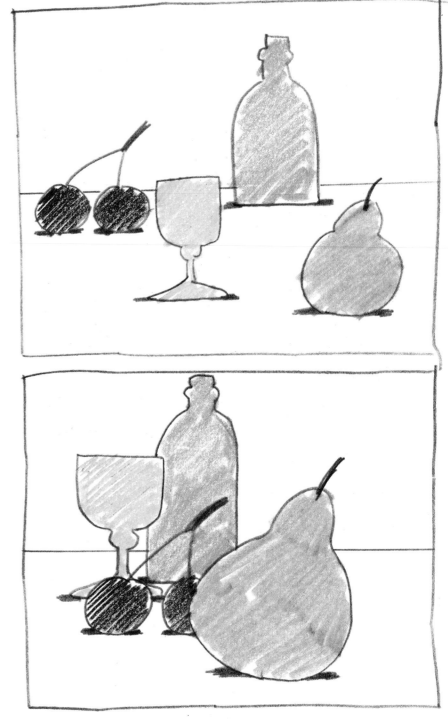

If we also change the sizes and allow the individual shapes to overlap, a more distinct picture results: The exaggerated pear is closer in the foreground, and the other overlapping elements recede into the background. The actual size of the objects is unimportant. This type of exaggeration allows the artist to add a certain expressiveness to his or her paintings.

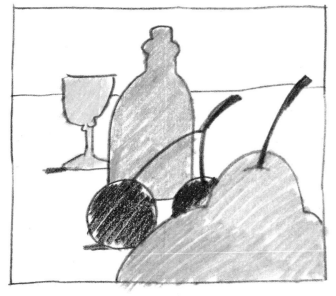

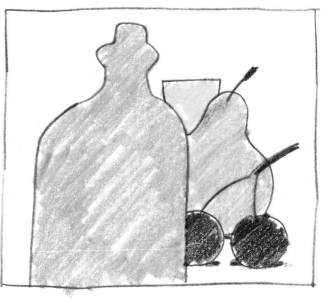

Let's look at a few compositions and the moods they express. Here the exaggerated, cut-off pear juts into the foreground, and the small glass gives the impression of distance, so the overall picture gains **depth**.

This composition gives the impression of **closeness**. Now the bottle is directly before the observer, and the other objects are grouped together behind it. This composition places all of the elements in the foreground.

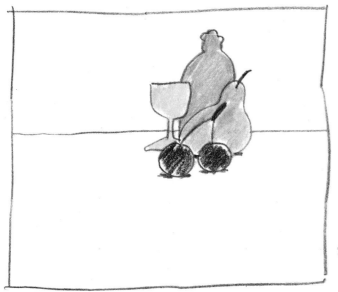

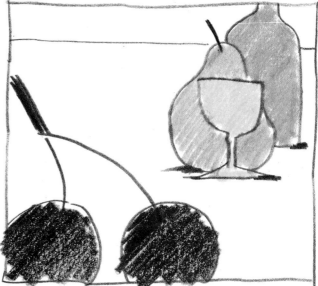

In this example, all of the elements are in the background, and none of the objects plays a singularly important role in the composition. They are surrounded by large, calm areas, which have a peaceful effect on the observer. The virtually symmetrical layout suggests an atmosphere of **tranquility**.

The smallest object now becomes the largest one. The cut-off bottle in the background is also unusual. The overall composition tends to "grate" on the observer, resulting in a feeling of **tension**.

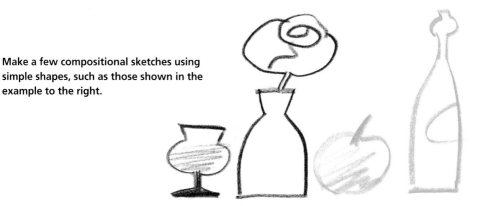

Make a few compositional sketches using simple shapes, such as those shown in the example to the right.

The sketches can be totally spontaneous. You can experiment with shapes and sizes—it will give you more confidence when composing your own paintings.

Working with Light and Shadow

Light and shadow are essential for giving your paintings a three-dimensional effect. If you are painting a representational motif, the best composition in the world won't help your picture if the objects appear flat.

Let's use a pear as an example. If you draw it using a simple line (left), it is definitely recognizable as a pear, but it doesn't have any volume. Now imagine a light source coming from the upper right. The light will cause a shadow on the lower left side of the

pear, making it appear rounder. It now has volume, plasticity, and a definite "pear shape," but it seems to be floating in thin air. It needs a cast shadow to make it appear as if it's standing solidly on a surface. The cast shadow is the shadow thrown by an object (right).

There are two types of shadows: the core shadow, which is found on the actual object and gives it its shape, and the cast shadow, which is thrown by the object and indicates the

object's relationship to a surface—that is, whether the object is standing on a surface or floating above it.

The core shadow is usually lighter than the cast shadow, because light reflects from the surroundings and brightens the core shadow.

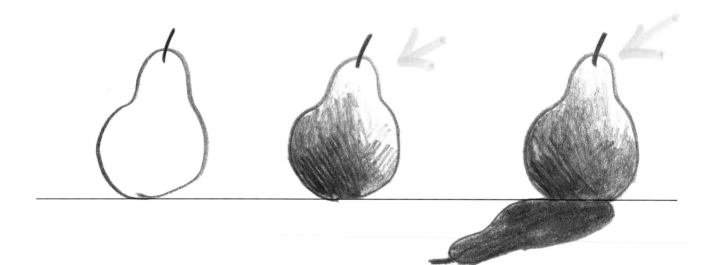

In contrast to landscape painting, in which the sun is the light source, you can select your own "sun" when painting still lifes. The length and shape of the shadows depend on the

position of the light source.

The higher the light source, the shorter the shadow—and vice versa. If you don't want a lot of shadows in your still life, you can incorporate just

a few shadows caused by a light source directly overhead to "anchor" the objects to a surface.

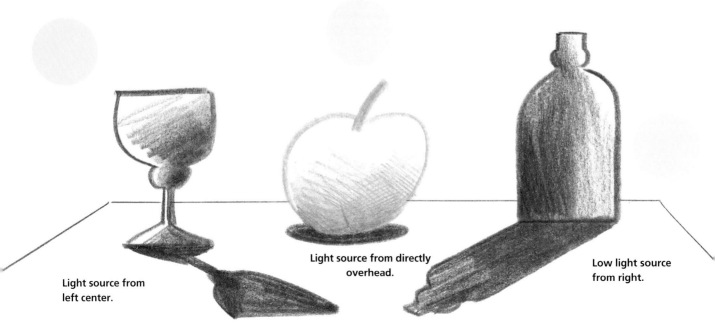

Light source from left center.

Light source from directly overhead.

Low light source from right.

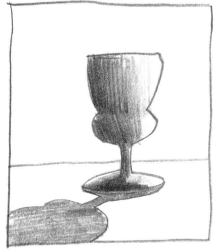 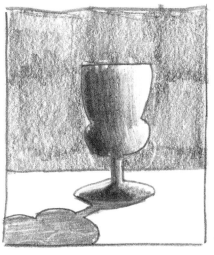 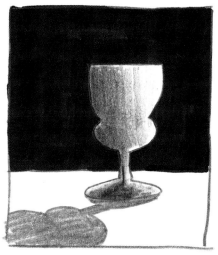

When painting shadows, you must remember that their tonal value and color are determined by their surroundings. Compare the three examples above. Do the shadows in all three pictures have the same value? If not, which one is lighter and which one is darker?

Even though they look different, all three actually have the same tonal value. They are influenced by the background—the darker it is, the lighter the shadow seems, and vice versa.

In order to get a feeling for light and shadow, try shining a light on a few objects from different angles. Sketch the positions of the shadows and the resulting changes in the objects. You'll be amazed at how different the same objects can appear in different lighting.

Students often ask if there is a "recipe" for coloring shadows. Unfortunately, there isn't. It's entirely up to you. You can, however, make shadows livelier by including colors from their surroundings. In the example to the left, you can see that the red of the cherries and the blue of the glass are repeated in the shadows.

Putting It All Together

Enough theory! Let's look at everything we've discussed so far in a finished painting. This unusual still life of an apple in a cardboard box shows a lot of depth. This effect is created as much by color as by perspective. The dark elements push the box nearer into the foreground than perspective alone could do. The areas that were left white underscore the impression of depth; the highlights on the apple make it seem fresh and crisp.

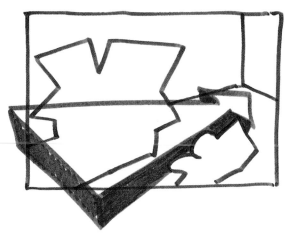

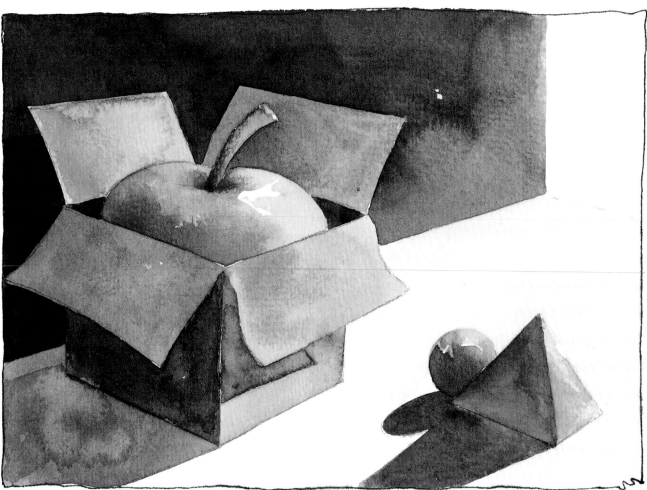

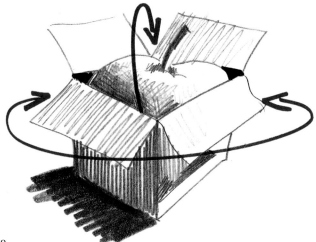

Light and shadow play important roles in this picture. They form the objects and add almost abstract elements. The warm colors of the box are repeated in the shadows—even in those of the apple, the ball, and the pyramid.

Notice that the core shadow on the box is darker than the cast shadow. This is simply because the box is darker than the surface, so the shadow has to be darker as well.

Look at the interplay between the positive and negative areas; it is an important component in the composition.

The picture to the right is an experiment in transparency. The cool colors let the water shimmer through the glass, while the white areas create highlights and reflections. This picture was painted on a dry background, and the paints were allowed to run together.

Shadows don't play such an essential role here as they do in the picture on page 28, but they are still important. You can see them on the edge of the glass and in the opening. The few dark spots make the glass appear round and indicate that the opening goes inward.

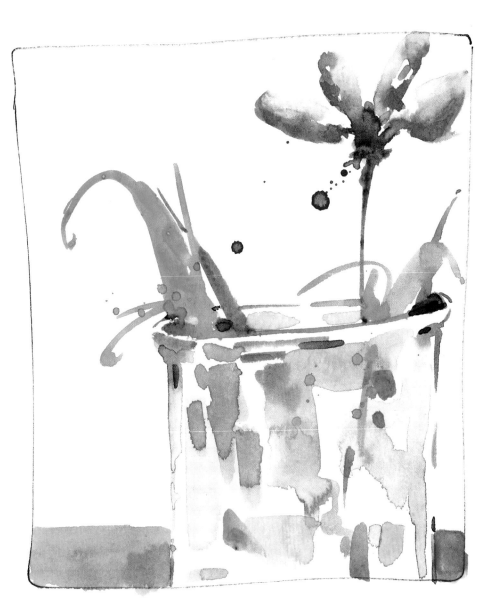

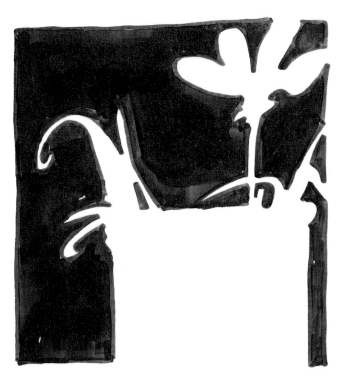

The thick, warm, ochre-colored line is sufficient to indicate the surface. It is darker on the right side than on the left. This gives the overall composition more plasticity or depth.

The distribution of shapes is particularly important. The flower that is shifted sharply toward the right creates an element of tension in the composition. Look at the negative space in the black-and-white sketch to the left. It forms individual, balanced elements in the picture that contrast with the dynamic motif. These elements are "loosened up" by the red spatters, which were added intentionally.

Sketches

The most difficult part of painting is transferring what you see onto a flat piece of paper. Like so many other aspects of painting, this can only be learned through practice. Thus, a sketchbook is an essential tool. You should use it to sketch anything you find interesting—small details or entire motifs, a vase or a chair. You can also draw or paint small scenes and impressions when you're on vacation.

To the right is a small sketch done in colored ink, which was slightly diluted with water. Below is a pencil sketch in which a few areas of color were applied using colored pencils.

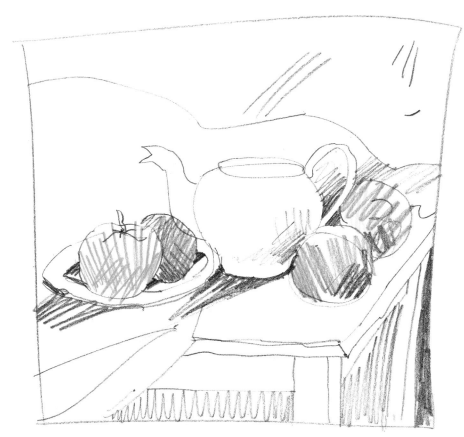

Many different kinds of sketchbooks are available. A hardcover sketchbook can be practical because you can lay it on your lap and make quick sketches without the paper bending. Instead of a sketchbook, you can use a journal-type book of bound blank pages. These books are nice because they protect your sketches. Another option is to use a piece of particle board with a clip for holding individual sheets of drawing paper. This setup allows you to experiment with different kinds of paper, and it's the least expensive option. You can also use ruled or graph paper, but the lines tend to be distracting.

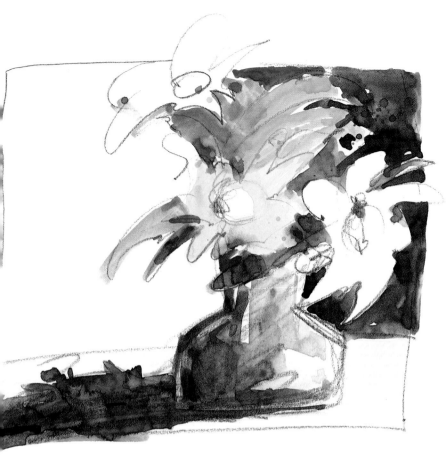

Virtually any medium can be used for drawing—from pencil to watercolor itself. Both regular and colored pencils are the least complicated to use. Inks and paints require a little more effort. For ink sketches, you can also try drawing with a technical pen that contains a cartridge of water-soluble ink. These can be used to achieve the same kind of lively stroke that you get with traditional pen and ink.

The drawing at the left was sketched in pencil; the colored areas were added later. The distribution of dark and light areas is more interesting than the flowers themselves.

In the sketch at the lower left, the base was applied with colored chalk, and then the larger areas were painted in using watercolor. The movement of the lines and the color combinations in the bottle and the bananas were of primary importance.

The glass below is a sketch for the picture shown on page 16. The highlights on the glass were sketched in as different shapes before they were transferred to watercolor.

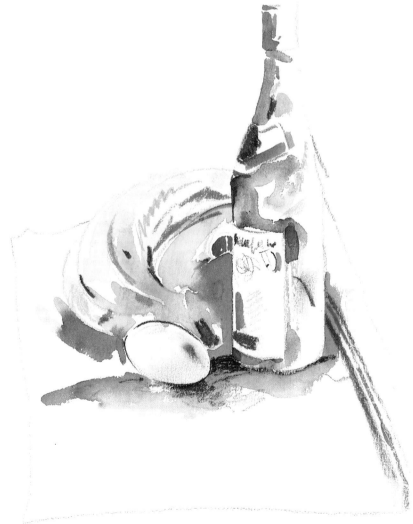

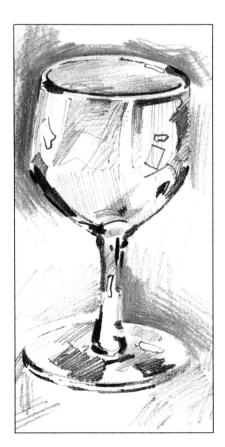

Painting a Transient Motif

with Jos K. Biersack

Wilted flowers can be just as interesting as fresh ones. Before you begin your picture, however, it's always a good idea to try out a few techniques. You'll gain more confidence and have more control over your painting. I began the painting shown here by doing this kind of experimentation.

Left: I applied the paint on the edges and then used a second brush dipped in clean water to model the shapes.

Below left: Here I used the same technique as above, but I let the stem run into the petals. Below: I applied the paint on the edges again and "pulled" it with clean water. This time I repeated the color of the stem in the center of the flower. The eye "blends" both parts, giving the flower more depth and connecting it more to the stem.

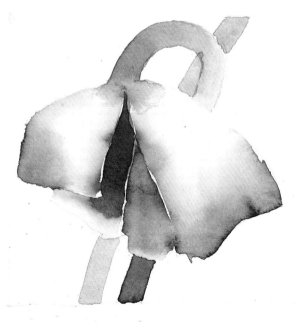

The colors and the "drooping head" (above) give the flower a wilted look. Leaving white strips between the colors can lend an interesting effect, too. To provide some continuity, I let the color of the stem flow into the petals. I used one hue for the petals themselves; it becomes more concentrated toward the center.

You can get some very effective results by spattering paint onto an area of wet paint. In this example, I applied the paint uniformly, beginning at the edges. Then I spattered a second color onto the first layer while it was still wet. I like to use a Japanese brush; it holds more water while maintaining a fine point.

Various flowers
(from left to right):

1. Dilute the paint in the center with clean water, lift out the excess color with a tissue, and leave the edges.
2. Apply the paint over a larger area, and then sprinkle water on it.
3. Completely cover the flower, and allow the green of the stem to flow into it.

You can make small areas more exciting by painting them uniformly and then dabbing water onto them. The water "pushes" the pigment and gives the entire area a lively effect.

Foreground and background come together in the above example. It was painted from the upper edge to the lower edge. After the paper had dried completely, a blue glaze was applied over the entire area. Always try to incorporate the natural flow of the paint into your compositions. Don't, however, be a slave to it.

When you paint a picture, try to tell a story, beginning with the selection of your motif. The story in my painting tells of transience. Fresh and wilted flowers are contrasted with one another, brilliant colors with dull ones. The composition should express something. In our Western way of looking at things, we view a painting from left to right. The eye follows the soaring lines and subconsciously perceives them as pleasant and cheerful. As you can see in the small compositional sketch, the fresh flowers lie along the "pleasant" line; the wilted flowers go "against the grain"—they point backward, a compositional expression of transience.

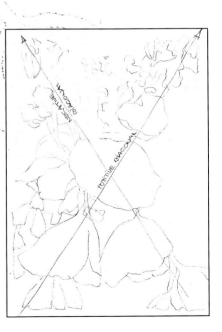

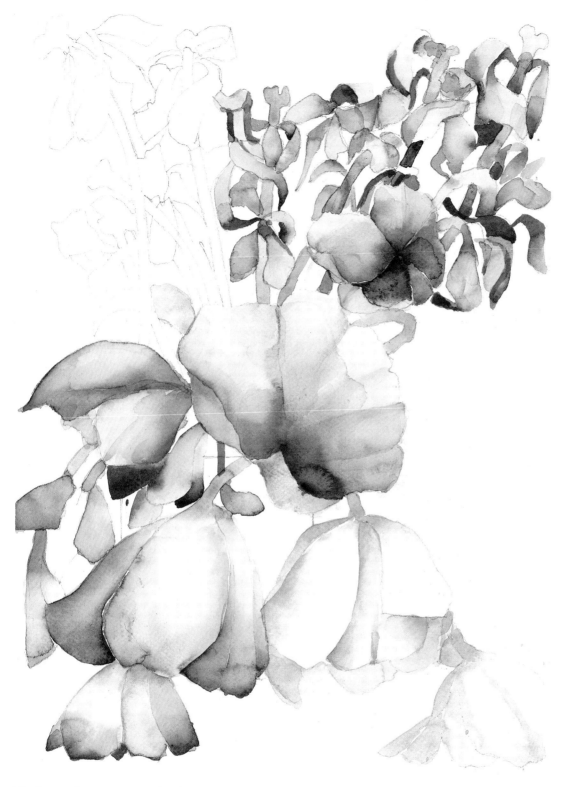

The largest flower is situated at the point where the compositional lines intersect, making it the dominant element in the picture. I prefer painting on cold-pressed watercolor paper, which lends itself particularly well for making corrections. I wet the paper with a sponge and then use tape to stretch it on a piece of particle board. I used four colors in this painting: cadmium red dark, sap green, Prussian blue, and ultramarine blue for the vase.

I began with the red of the fresh flowers (see page 34) and, as previously mentioned, used two medium brushes—one for paint and one for water. I painted in large areas of light and dark shadows, always allowing one layer to dry before going on to the next. The second color I applied was the green, and I used only one brush for this application. After I had painted a stem, I put a drop of clean water on it. The water "pushes" the pigment to the edges of the stem, where I was able to incorporate it as a line, thus giving a three-dimensional effect to the painting.

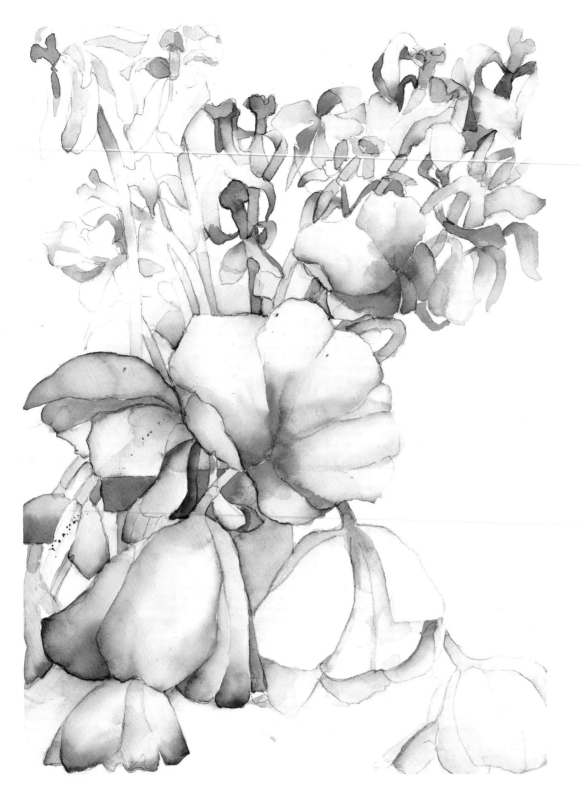

Next I turned my attention to the wilted flowers, which I painted in blue and green. I painted the wilted stems and the drooping petals, as well as a portion of the background, in order to get an idea of the color scheme I would use.

I accentuated the vase with ultramarine blue, allowing a little of the green from the wilted flower to blend in as a highlight. As I said before, I always wait for the individual layers to dry before I continue to paint. Sometimes I

need distance from my painting, so I take a break. When I come back to it, I see it in a whole new light. I often discover weak areas that I didn't notice before. In this example, you can clearly see the interplay between positive and negative space (we've already discussed this on pages 22 and 23). It's a good idea to step back and look at the entire painting, even when you're working on details.

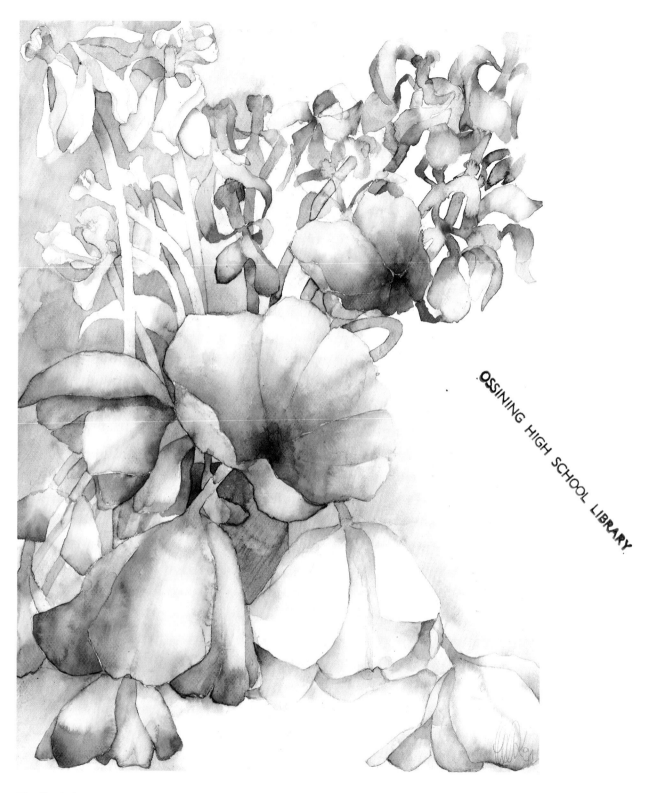

The final phase involved working out the background. As always, the painting was completely dry before I applied this layer, which was painted in green. Never simply "fill in" the negative space. You'll end up with something that looks like a child's painting. These areas needed to be modeled to make them more interesting, so I applied some blue to the background as well. I fixed some of the dark spots and emphasized some areas, such as the red and blue in the flowers. The most difficult part of painting is knowing when to quit. You don't want to "overpaint."

After everything is dry, you can take out pencil lines that are too dark or too dominant with a kneaded eraser.

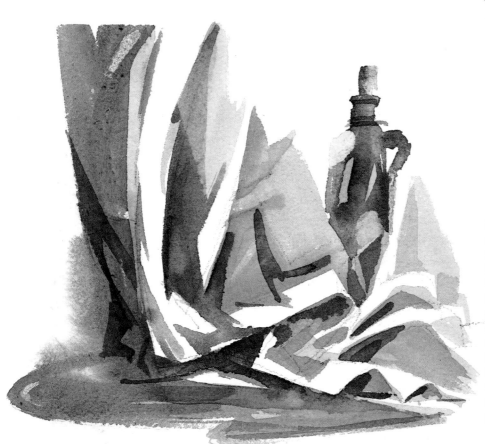

Painting a
Classical
Still Life

with Eberhard Lorenz

Painting folds in material isn't easy, but it's always interesting. A material can flow or it can be "choppy"; it can hang, swing freely, or be draped across something; gentle waves or sharp edges can form. In classical still lifes, you often find fruit or flowers in front of a curtain or draped material. If you'd like to try painting this type of motif, I've provided a few examples here to get you started. The top example shows a gathered fabric that flows gently to the side—curtains sometimes look like this.

If the fabric has a pattern, don't let it confuse you. Concentrate entirely on the folds and their shadows. The folds in the example to the left were pressed together, and the fabric flows to the floor. You can see that this makes it seem more angular than the example shown above. Try to see the folds as abstract elements; concentrate on their shapes. As you know, negative space is just as important as positive space. This isn't so obvious here, since the fabric doesn't have any particular shape.

Begin with black-and-white sketches. Try to capture light and shadows, which give shape to the folds (above). Even if the fabric doesn't contain any pure white, the light areas help give an impression of individual folds. Squint your eyes and look at the motif. This makes it easier to see the different areas between the folds.

Including additional elements in the painting simplifies the task of indicating where the fabric is situated and what it's made of. A vase or bowl embedded in the fabric gives an impression of where the fabric is and can make it seem more three-dimensional. Patterns in the fabric also emphasize the folds.

The interrupted blue strip in the example shown above gives the fold more height. Concentrate on how the colors change in the shadows.

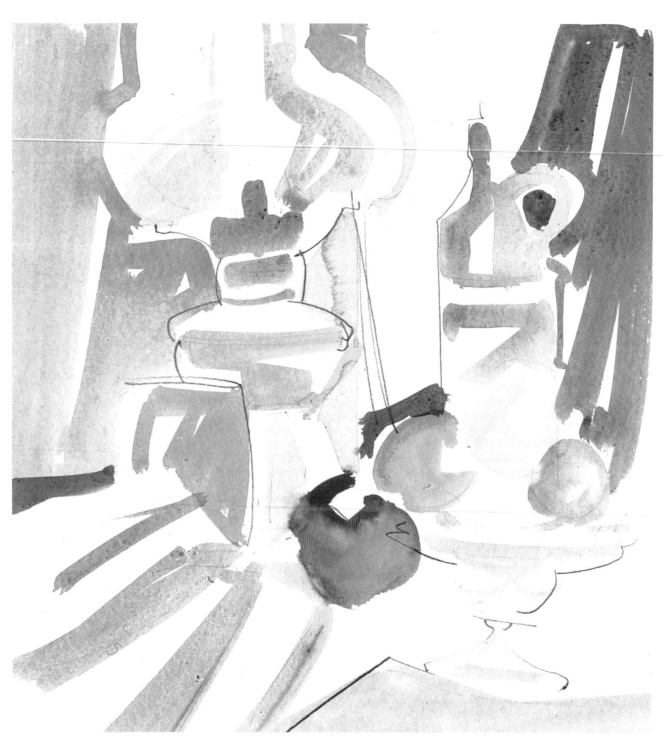

Fabric reflected in an old oil lamp—an interesting motif. In order to give it more color, I added a couple pieces of fruit. First I sketched the composition using a soft pencil. Except for the flowing movement of the fabric, the elements in the painting are all very static, so I decided to add more movement—thus, more excitement. I created small sketches to experiment with different ideas. Then I used a broad brush to apply the first areas of color.

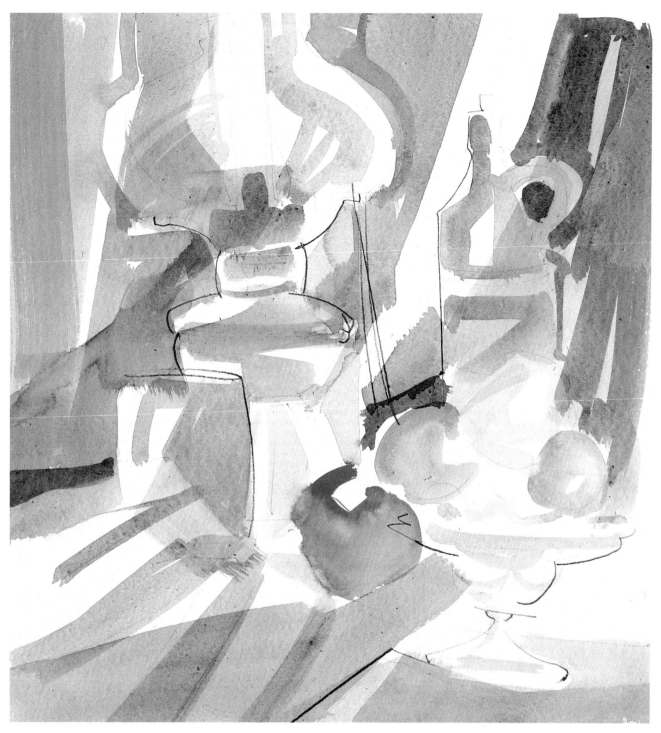

Colors used:

Prussian blue
alizarin crimson
ultramarine blue
chrome yellow

At first, I left as much white showing as possible. I didn't want to sacrifice the light areas too soon.

Remember: Material that butts up against an object gets "bunched up," causing angular shapes in the light areas. When you continue to work on a painting, you should make sure that these areas don't get lost. The contrast is provided by the round shapes of the fruit and by the bowl. I carefully made the background

darker, applying the foreground shadows using a glazing technique. The warm red and orange contrast with the cool hues behind the lamp.

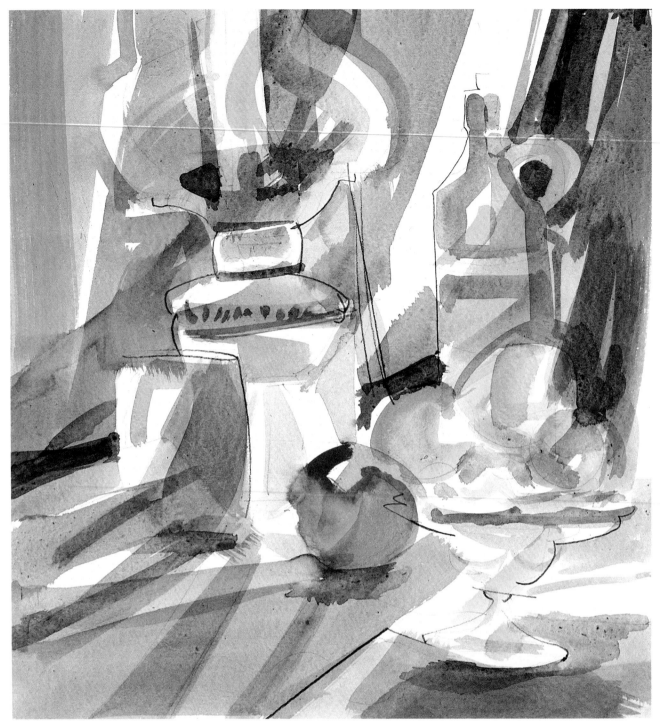

The areas slowly began to lose their "anonymity"; they became more distinct and, to some extent, more cohesive. I used a round brush for the details—for example, accentuating the colored highlights. I gave the oil lamp a flame and the fruit more plasticity (three-dimensionality). I generally use water very cautiously when I paint. Too much wet-in-wet can destroy the impression of folds in material. Most of the time, I wait until the paint has dried before I paint over it again. Note the highlights in the background: The blue shadows in the background make the bottle seem more three-dimensional, and additional shadows give shape to the material.

The colors should complement and echo one another. Keeping that in mind, I used the warm red of the apple in the foreground as well as in the background, which gives the painting more coherence.

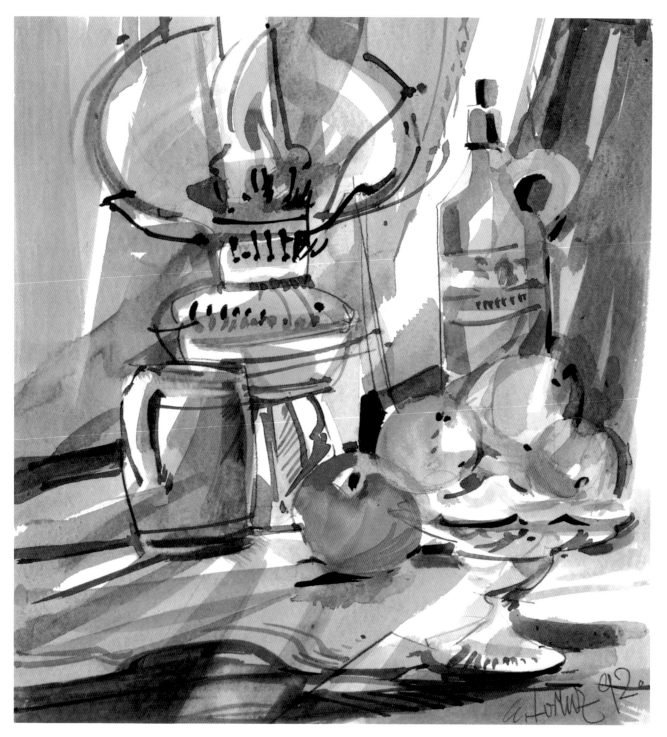

The final step involved working out the details, applying highlights, and making improvements. To provide contrast, I drew with the brush (no. 6 sable) while holding it like a pencil. On a dry background, the distinct lines support and enhance the shapes of the individual elements in the painting. The lamp supports the glass, the brown lines make the mug seem rounder, and the pattern on the material accentuates the folds.

A little trick: If you just can't seem to paint the folds, add a few stripes to the cloth. The cloth seems to "well up" where you paint them (right).

Make a quick stroke to add shadows, and your folds are salvaged.

The line trick: If the folds aren't turning out the way you'd like, you can model them by painting lines in the cloth.

Painting a Shoeshine Motif

with Karlheinz Gross

Still lifes can be found anywhere—you simply have to look around. You can find still lifes at the breakfast table or in the bathroom at night when you're brushing your teeth. It doesn't necessarily have to be apples arranged in a bowl and set against a backdrop of folds in a tablecloth (although I'm a great admirer of Cézanne's still lifes with fruit).

I discovered this still life one sunny winter morning when I was shining my shoes. The sun threw long shadows, resulting in an almost abstract composition. Since shadows change quickly, I grabbed my Polaroid camera and "captured" the scene. I also made a few sketches in soft pencil (number 6) to help jog my memory.

I liked the contrast in this motif between the elegant women's shoe and the clunky men's boot, the red against the black, and the green brush as a highlight. Most of all, however, I liked the shadows, which created entirely new shapes.

After I had taken a photograph and made a few sketches, I set up all the objects on a big table. Then the second stage of my work began.

I created a few dark-light studies, tried out a few color schemes, and, above all, began to sketch my motif more precisely. When you're painting a still life, you've got plenty of time to practice sketching your motif, since it won't change or run away. You can also take breaks and then continue working when you feel like it and have the time.

Below: A quick pencil sketch I made to "capture" the position of the shadows.

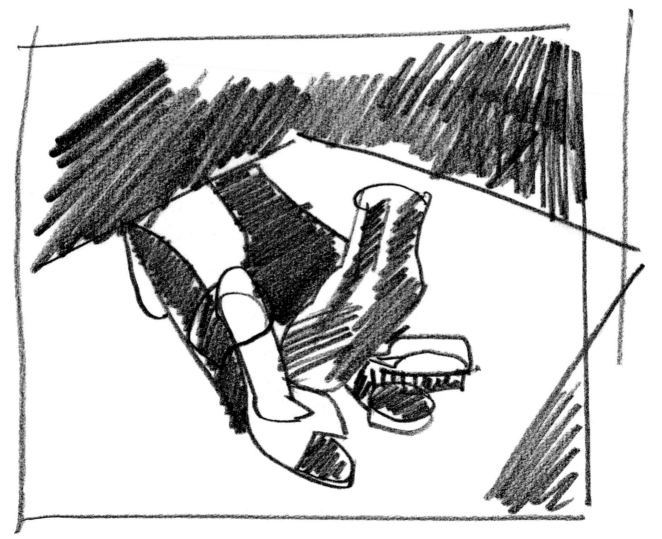

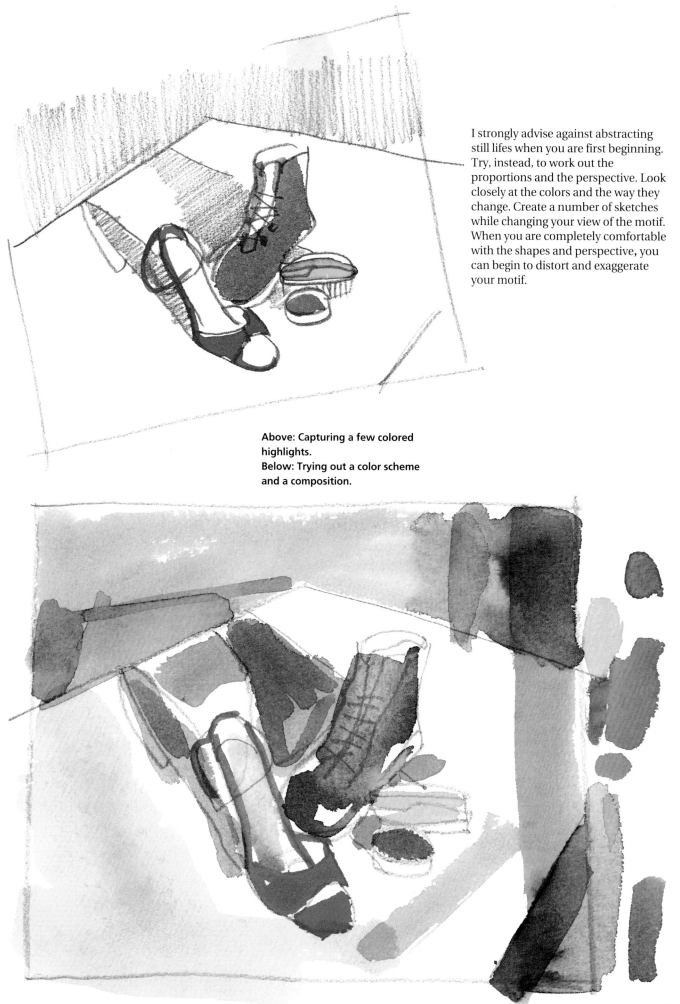

I strongly advise against abstracting still lifes when you are first beginning. Try, instead, to work out the proportions and the perspective. Look closely at the colors and the way they change. Create a number of sketches while changing your view of the motif. When you are completely comfortable with the shapes and perspective, you can begin to distort and exaggerate your motif.

Above: Capturing a few colored highlights.
Below: Trying out a color scheme and a composition.

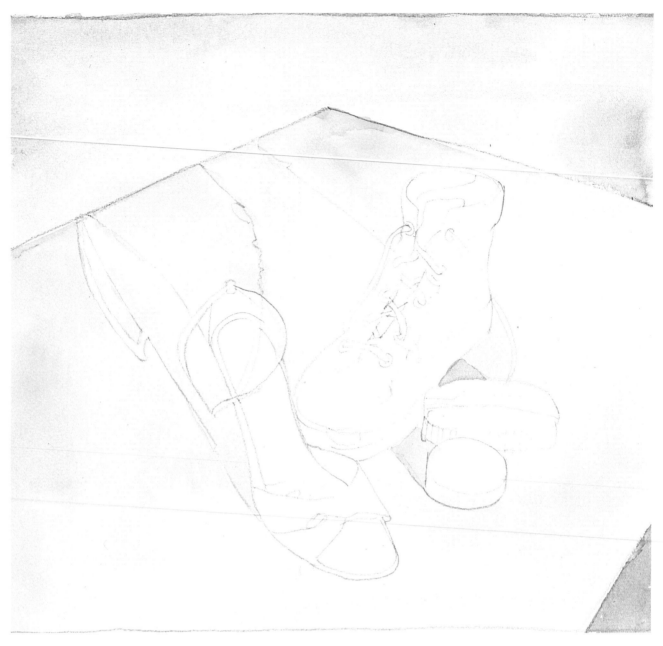

I selected the most appropriate composition from all the sketches and lightly sketched it directly on the watercolor paper with pencil.

Then I laid down the base using a thin coat of yellow ochre and a neutral gray. (I use a form of liquid watercolor paints that are similar to colored ink. These paints can be mixed with one another or with tempera paints.)

Try to make the first layers of paint very delicate. They can always be intensified later. At first, you don't have to apply the actual color of the background—you're simply indicating the general direction in which you'll be working. Don't worry if the pencil lines show through; they can contribute to the composition and emphasize the transparency of the medium.

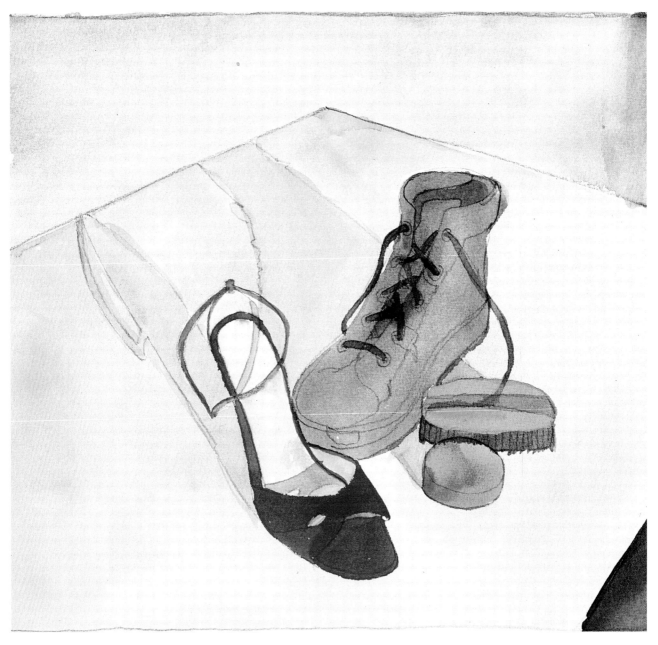

In the second step, I painted over the gray of the shadows with the ochre of the background.

I carefully applied the base to both shoes. Since I had already decided not to have any white areas showing in my painting, I filled in everything with color.

Next, I applied the first coats of dark paint to the foreground and to the background.

Always keep an eye on the entire painting, so you don't get caught up in details. It's a good idea to occasionally get up and look at your painting from a distance. When you do this, make sure the light and dark areas are distributed evenly. I used indigo for the shadows in the shoes and painted over the large cast shadows with thinned Prussian blue.

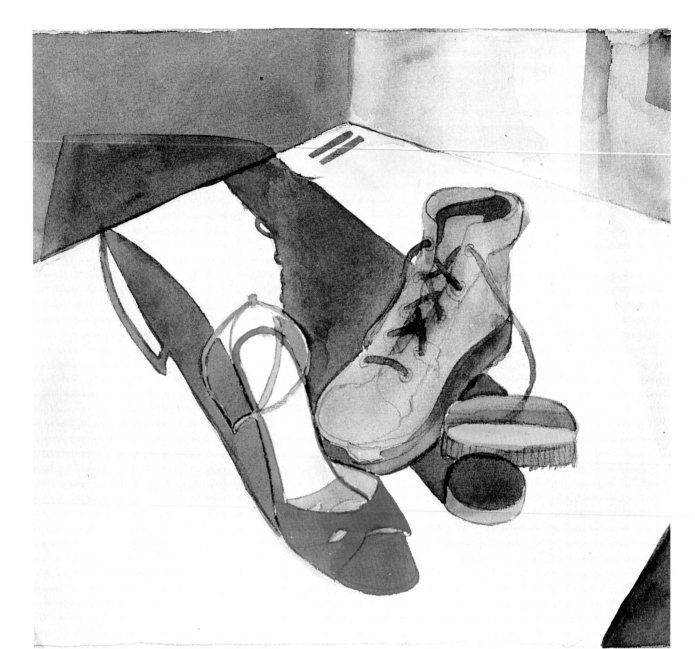

I gradually darkened the brush and the can of shoe polish, and I increased the intensity of the shadows and the background. Always leave room to add contour lines with a fine brush if necessary (so don't use black!).

The background, which is a necessary but not decisive element in the painting, allowed me the chance to use my imagination. A little flesh color, Prussian blue, and turquoise or thinned neutral tint wiped across the ochre of the background gave me the opportunity to experiment with composition.

Unfortunately, there are no rules on how to mix shadows, but bear in mind that they are never simply black or gray. Experiment with a few mixtures. In this example, I created shadows by mixing chrome yellow with cobalt blue and Prussian blue with violet.

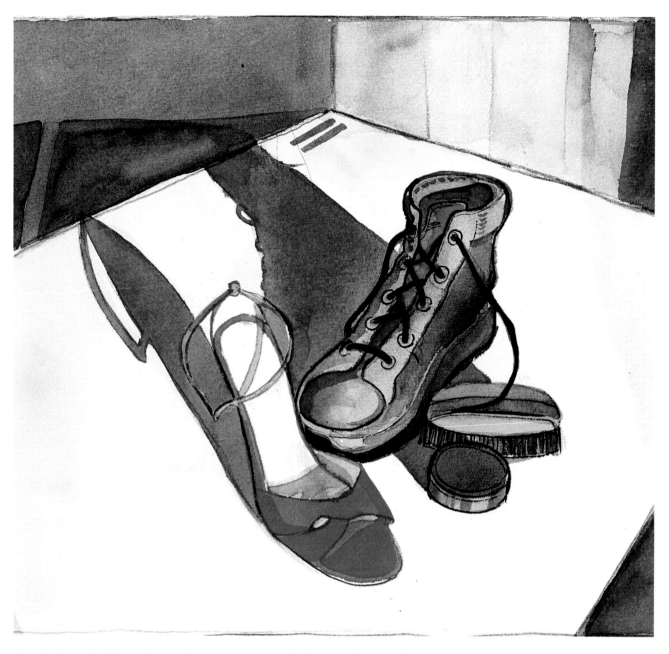

As a final step, I added a fine outline to finish off the shoelaces, the eyelets, the bristles, the stitches, and the can of shoe polish. Before I did this, I made sure the entire painting was dry. I intensified the shadows in the boot to make it more three-dimensional.

It's always difficult to know just when to quit painting. It's easy to want to keep painting and make the picture more realistic and more precise—especially in the case of still lifes—but, before you know it, the spontaneity will be lost. It's better to quit a little prematurely than to paint your picture "to death."

By the way, I did end up polishing the shoes—eventually.

Painting Objects That You Find

with Brian Bagnall

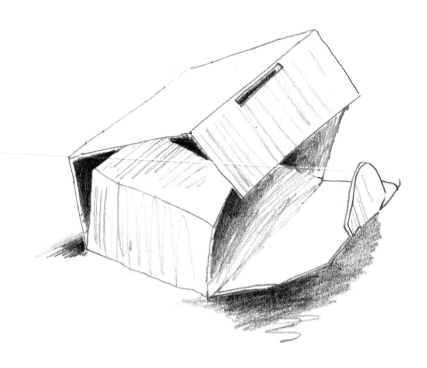

The nice thing about still lifes is that the objects really do "hold still," which makes it possible to paint them at your leisure. You have to paint landscapes quickly because of fleeting light or atmosphere, but you can take your time with still lifes, experimenting with light and composition. I like to make a number of preliminary sketches, because shapes and their relationships to one another are very important. Positive and negative space also play a very significant role.

In the case of the box, which is folded and slightly open, I was

interested in light and shadow. The opening gives this rectangular shape a completely new dimension. The dried plant, with its interesting shape and rough quality, provides a good contrast. I added two rocks that I found on the beach. The red one, which had been worn smooth by the water, has a completely different texture than the gray one, which contains some interesting markings. The soda can seems a little out of place; it doesn't really have anything to do with nature but, unfortunately, can often be found lying on the beach. This all sounds as if I had intentionally collected objects that are related to one another in some way. I often take hours to figure out which objects to include in my paintings and how to arrange them. For example, before I had decided on the red rock and the gray rock, my composition included a green rock and a piece of wood, and a tennis shoe occupied the soda can's spot. When I began, I was certain of only one thing: The still life would be set against the bright blue table and the yellow wall.

Arranging the individual objects takes time, too. I was constantly shifting them around to see how the light and shadows changed and how the areas balanced against one another. I made sketches throughout the process in which I captured the main colors, but, more important, I was interested in deciding on the final composition and the view.

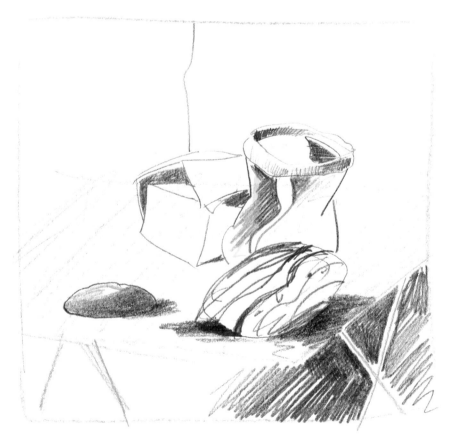

The borders of the picture are decisive elements that affect the individual shapes. As discussed in detail on pages 22 and 23, the negative space between the motif and the edge of the picture is just as important as the shapes of the objects themselves. This still life shows the interplay between positive and negative space particularly well—for example, interesting new shapes form between the diagonal table legs.

Based on all the different sketches I made, I finally decided on the composition to the right. The individual areas in this picture are planned precisely, especially the part underneath the table, where the diagonal lines form triangles. While the areas in the center of this section remain tranquil, the outer areas are livelier without disturbing the composition on the surface of the table.

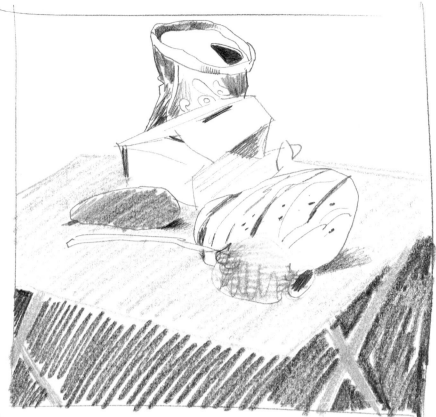

After completing this thorough preliminary work, I carefully transferred the sketch to watercolor paper. To do this, I first traced the composition on tracing paper and then turned it over and covered the back of the tracing paper with graphite from a soft pencil. Next, I placed the tracing paper, graphite-side down, on the watercolor paper and re-traced the composition, transferring the lines to the watercolor paper. You can see how this works in the example below: The broad gray areas show where I rubbed over the sketch with the soft pencil; the dark lines were traced through to the watercolor paper.

I decided on a classical pyramid arrangement for the objects themselves. This composition is simple and self-contained and helps to accentuate the differences between the objects.

I used these preliminary colored-pencil sketches to create watercolor sketches for experimenting with color schemes. I used scraps of different types of paper to see the effects of the various textures.

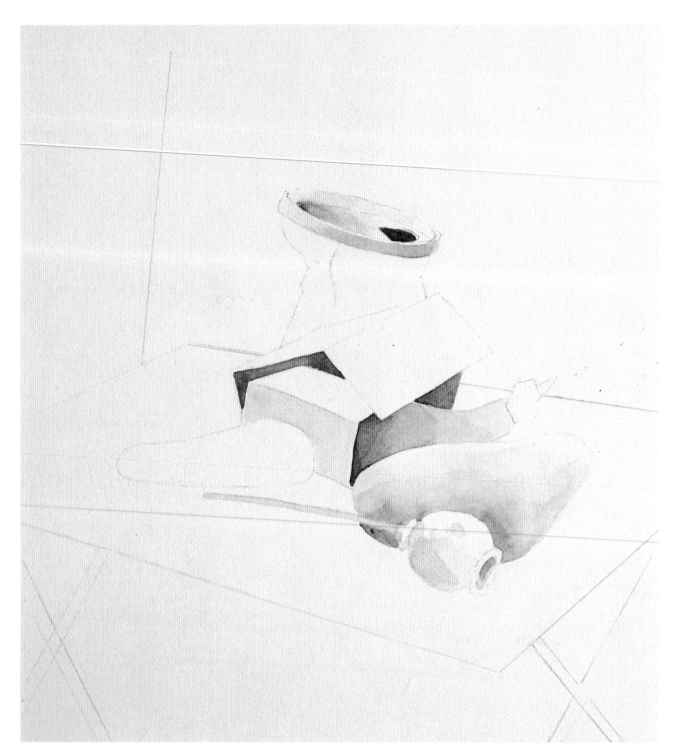

Colors used:

cadmium red
alizarin crimson
ultramarine blue
cerulean blue
yellow ochre
Naples yellow

Be very careful when you're transferring or roughing in the basic composition. It's better to leave a few extra pencil marks than to erase on watercolor paper. Pencil marks can actually be very interesting in watercolor paintings, while erasing can quickly damage the paper.

I began with the more delicate hues. The grays form the box and helped me to rough in the exact shape. I also painted in the rough shape of the dried plant.

A white box doesn't necessarily have to be pure white. In the picture to the right, for example, the shadow on the side of the box reflects the blue of the surface, and the front of the box reflects the yellow of the background. The shadows on the inside were painted using Payne's gray and yellow ochre. Despite all these different colors, if you asked somebody what color the box is, he or she would definitely answer "white."

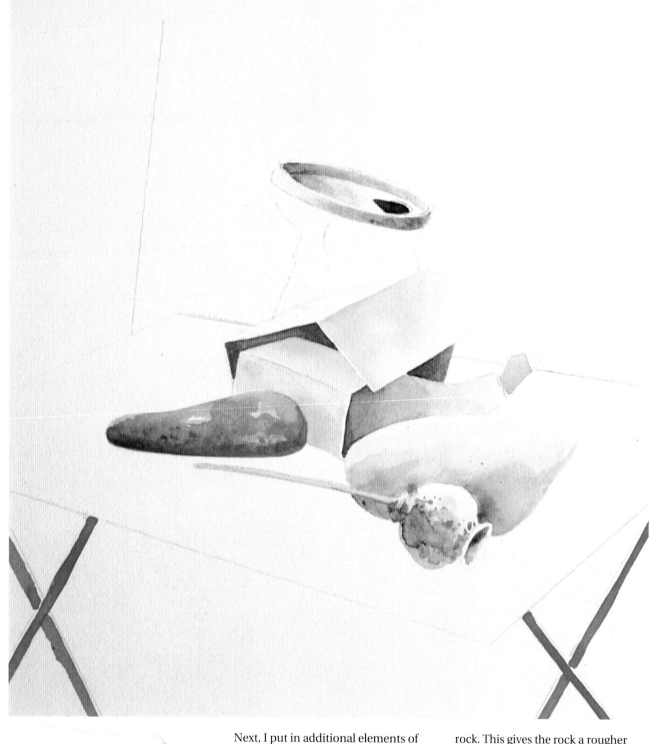

Next, I put in additional elements of the composition and accentuated the shadows. The colors of the background are reflected in the large rock and on the top of the soda can; however, I actually painted the background last.

I painted the red rock using a graded wash, from light to dark. At this stage, it is important to concentrate on shadows so the objects appear to stand firmly on a surface, not floating in space.

Just before the paint dried, I used the tip of the brush to add the red and blue to the core shadow on the red rock. This gives the rock a rougher texture, and its surface provides a contrast to the surface of the box.

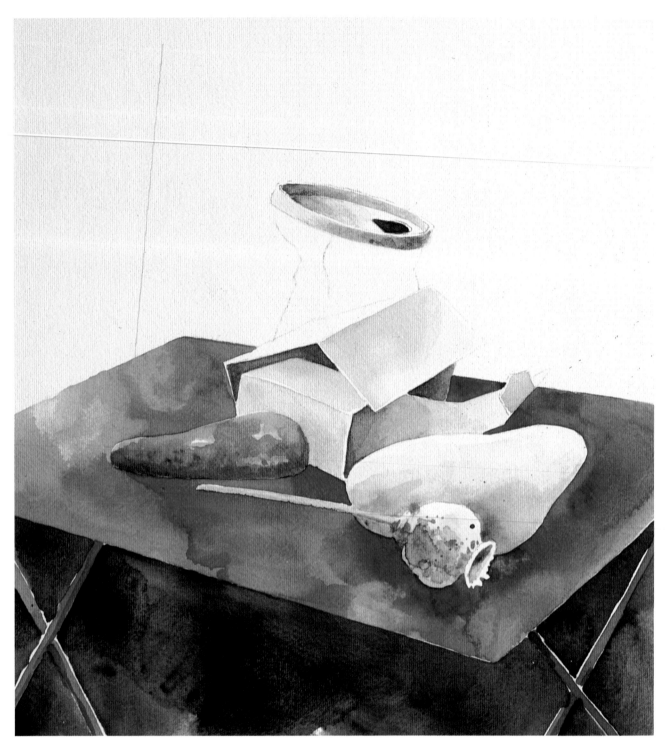

Then it was time to paint the metal table, which dominates the composition with its color. I was particularly interested in blue, so I took some cerulean blue with a touch of ultramarine and applied it with a little water. The cool blue contrasted against the warm hues of the other objects, creating a unique and interesting warm-cool atmosphere. Although the real table is actually solid blue, I left the textures caused by the paint. I intentionally avoided adding other colors to the surface of the table—for example, highlights—since the effect would be too busy. Additionally, the power of the contrast would be lost, and the clear composition would suffer.

I painted the "floor" with dark colors (Payne's gray with a little alizarin crimson), so the triangles below the table wouldn't dominate the picture too much and the tabletop would remain the important element. The floor retains interest, even though it recedes into the background.

Remember: Don't just plunge into details when painting this type of motif; otherwise, you'll lose sight of the overall composition. Step back from the painting once in a while and view the objects from a distance. Look at the box, the rock, and the can as a self-contained motif rather than as individual objects.

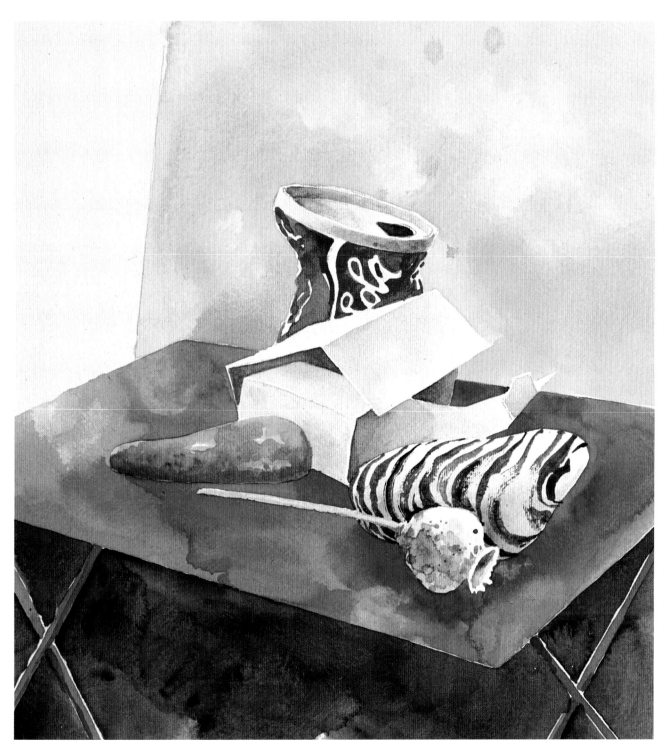

Before I completed the final details, I spent some time working on the yellow wall in the background. I carefully experimented with different color mixtures on a separate piece of paper, because I didn't want to risk ruining the whole painting by botching the background. The old rule applies here: If you're unsure of yourself, begin with lighter hues; you can always make them darker.

I applied Naples yellow and ochre, adding a few spots of Payne's gray to enliven things.

I gave a lot of thought to the combination of the background and the table and finally decided to leave a portion of the wall white. This area supports the pyramid-shaped structure of the composition, and the vertical line leads to the focal point of the picture.

I added the final details last. I used a dry brush to give the gray rock texture, and I used the lines to emphasize its irregular, round shape. I also experimented with this element on a separate piece of paper before I began to paint. The crushed shape of the soda can is accentuated by the vertical lines.

I let the white paper show through and worked with cadmium red, using alizarin crimson for the shadow areas.

The most difficult thing about painting is knowing when to quit. It's usually better to quit a little too early than a little too late.

Experiments

The only way to master special effects is to practice. So don't be afraid to experiment. In the illustration shown below, for example, scratches were made in the paint. There are two ways of doing this: You can scratch textures into the paper before you apply the paint. The paint wells up in the scratches and dries.

Lifting out paint: Above, a small sponge was used; below, a tissue. The resulting textures can be used as a pattern or as a component in a plant.

Above: This effect was achieved by continuously painting over liquid frisket. All of the layers of color shimmer through. In the example below, the bottle was drawn in first using a white candle.

Or, you can scratch into dry paint and then paint over it again. This often results in completely new hues. You can also get some interesting effects by scratching with colored pencils.

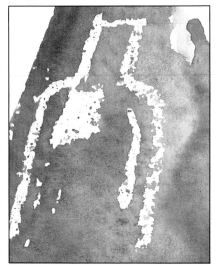

Bizarre shapes result from blowing the wet paint in different directions using a drinking straw.

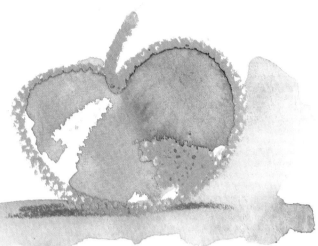

If you do things like draw into your watercolors or use opaque white paint, there will always be people who think that it's not "genuine" watercolor painting. And this may be true. But the single most important thing to remember is to have fun. Why should you let anybody stop you from experimenting? Even Turner painted on gray paper and used opaque white. To the left is a combination of oil pastel and watercolor. Of course, the two media can't actually be mixed, since oil repels water, but you can get some interesting combinations anyway.

In the little experiment to the right, pastels were mixed with watercolor. The pastel partially mixed with the water. You can get some good highlights by using this type of rough paper. Rough textures result if the pastel doesn't completely cover the surface.

At right is a very unusual combination. The background is watercolor, the bottle was created using white and colored wax crayons, and the produce are photos taken from a mail advertisement. If you like to create these types of experiments, set up a file where you can keep pictures of fruit, plants, and other things that you may want to use later.

A Few Tips

You won't always be able to find a suitably colored background for your still life. Sometimes you might like the shapes of the individual objects, but the colors aren't quite what you're looking for. In cases like these, there's only one thing you can do: try out different color combinations. You won't always feel like making the same sketch over and over again using different color schemes, so sketch the motif once, and then make some photocopies on woodpulp-free paper (right).

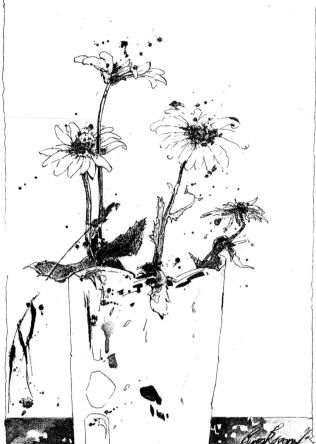

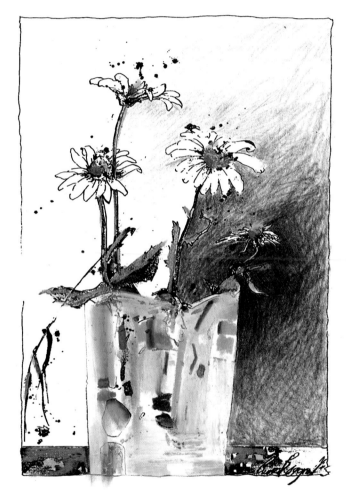

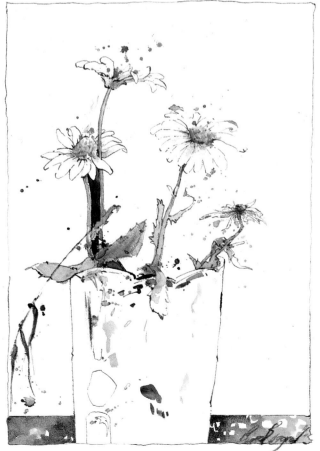

Next, try out different backgrounds, varying the colors of the individual objects or shifting the emphasis of the colors. Depending on how exact you want to be, you can use felt-tip markers, chalk, or colored pencils. If you use watercolors, the paper will buckle. Don't let that bother you, though—it's only a preliminary sketch.

In the example above, the glass and its highlights come first. Next, the brown background was applied in order to bring the glass nearer into the foreground, but then it looked like the flowers weren't playing any role at all. Then the flowers were emphasized, and everything else became secondary. As always, it is important to pay equal attention to positive and negative areas.

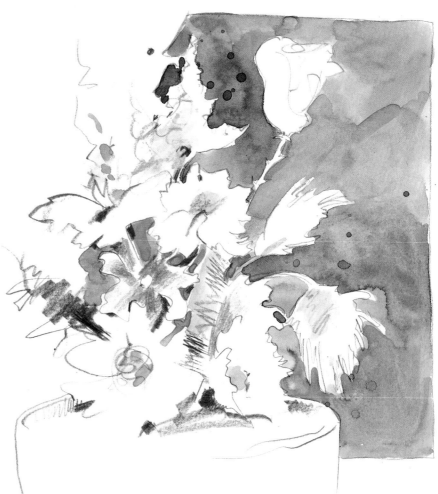

You'll hear over and over again that watercolor paintings can't be corrected. This isn't entirely true. A painting can often be salvaged if you abandon your original idea and create something completely new. The simplest way to do this is to use a movable frame to cover up the "botched" portion of the painting so you can see only the part you like. (Of course, this won't work if the botched part is right in the center of the painting.)

Backgrounds are often a problem. In the example above, the restless background textures distract from the restless motif. To fix this, the background was painted blue. This brought the plants closer into the foreground, and the shapes that were left white create an additional effect.

It is also possible to carefully wash off areas of paint that you don't like. You can get some interesting textures by doing this, which you can then paint over (below).

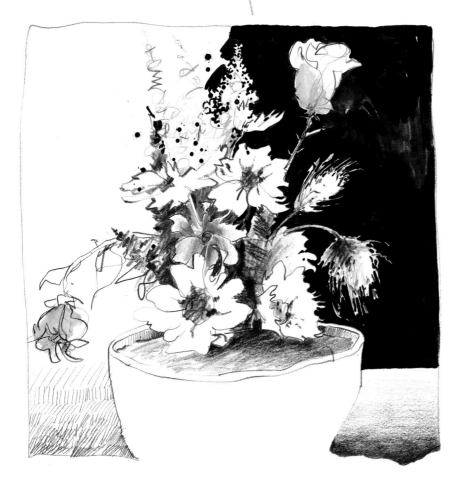

Motifs for Inspiration

You can create still lifes anywhere and from anything. Nonetheless, this is sometimes easier said than done, because you can get so used to things that you don't even notice them anymore and don't think of them as potential motifs. Strictly speaking, a still life can be anything that doesn't move. A parked bicycle, a crumpled paper, or a pair of eyeglasses lying on a book—all are possible subjects. You simply have to use your imagination. To give you some ideas, a few still lifes have been assembled on these pages. Maybe you'll feel like putting them on paper.

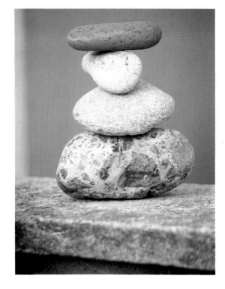

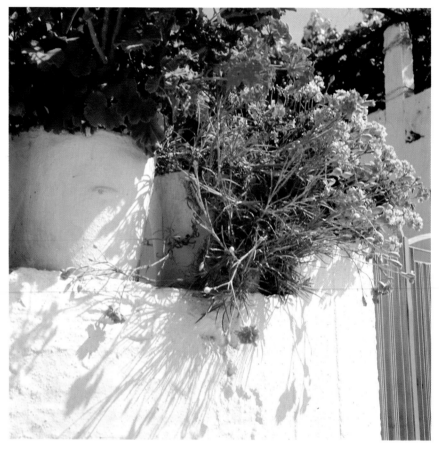

Colorful, but not too busy—that's how the "stone tower" shown above can be described. The interesting thing about this motif is the various textures and patterns it contains. The diagonal line created by the slab at the bottom could be exaggerated and is an important component in the composition. You could also divide the background into different shapes.

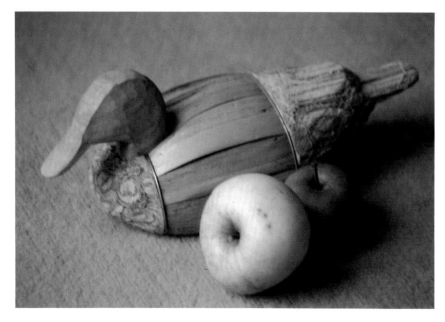

Flowers don't always have to be in a vase on a table. In the picture above, the shadows on the wall are particularly interesting. Of course, you already know that shadows don't have to be gray. Experiment with the white (refer back to the cardboard box in the still life on page 53). If the cut-off gate or the shrubbery bother you, simply leave them out.

The wooden duck to the left is fairly straightforward, but it's not easy to paint. The shape can be emphasized by the lines in the material. A shinier, more brilliant contrast is provided by the apple. You can also add other objects if you'd like.

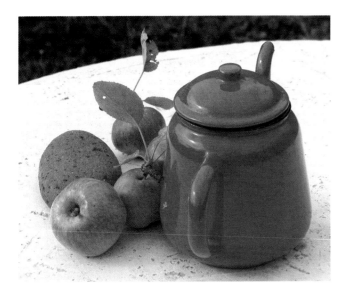

You can find a lot of round shapes in the example at the upper left: The apples, the rock, the coffeepot, and even the table can all be broken down into circles and ovals. The edge of the stone table, which runs out of the painting, provides excitement, as do the various textures of the objects. If you feel there's too much red in the picture, simply change the color scheme.

Even the picture above can be considered a still life: slightly moss-covered wood bathed in sunlight. You can use liquid frisket for this motif, or you can scratch or draw into the paint (see the experiments on pages 56 and 57).

Below are a few more folds to practice. The red stripes of the cloth help provide shape, and the red is repeated in the lid of the container and in the fruit.

A less-than-perfect photo was intentionally chosen for the example shown above. It leaves more room for imagination. A perfect photo is already a finished composition and doesn't leave much room for experimentation and new ideas.

The stark light forms strange shadows, causing the vegetables (which, by the way, are made of silk) to take on new shapes. The positive and negative areas are particularly important, and they're also influenced by the lower edge and the cut-off frame behind the bowl. Leave out elements that you think are superfluous, and exaggerate others if you think it's necessary.

Glossary

abstraction
An image simplified into color, pattern, and form. The popularity of abstract art has spread since 1910.

cast shadow
A shadow created when an opaque object blocks a light source. The size and shape of the cast shadow are influenced by the position of the light source and the surface upon which it is cast.

chalk
Chalk, together with pencil and charcoal, belongs to the "dry" drawing media (as opposed to "wet" media such as ink or watercolor). In addition to white chalk, various other types of colored chalks are available, such as oil pastels, soft pastels, and wax crayons.

core shadow
The shadow found on an object. The core shadow is almost always lighter than the cast shadow and gives an object its shape and three-dimensionality.

glaze
A thin, transparent layer of paint applied over dry paint. Because the glaze does not completely cover previous layers of paint, it is possible to achieve delicate mixtures and subtle nuances. The transparency of watercolors makes them especially suitable for glazing.

liquid frisket
A kind of masking fluid that can be rubbed off when dry. In watercolor it is especially useful for masking areas of white.

negative space
Space that forms between objects in a motif or between the motif and the frame.

neutral tint
A dark, gray-blue watercolor or ink.

plasticity
The effect of three-dimensionality. Just as the sculptor can model a three-dimensional figure, the painter can use techniques to achieve the illusion of depth and shape. *See also* **core shadow**.

positive space
The areas formed by the actual objects in a painting. Positive and negative space are always interrelated.

rubber cement
See **liquid frisket**.

warm and cool colors
The two basic divisions of the color wheel. Yellows, oranges, and reds are generally regarded as warm colors, and greens, blues, and violets are generally considered to be cool. In the twelve-color wheel, yellow is the warm pole and violet is the cool pole. The temperature of the colors between them is relative to the colors with which they are contrasted.

wash
An application of diluted paint that covers large areas of paper. A wash is laid from top to bottom on wet paper with a thick brush or a sponge.

wet-in-wet
A technique of working with fresh paint on a wet surface. Working wet-in-wet allows the artist to achieve soft blends and delicate contours.

wet-on-dry
A technique of applying fresh paint to a dry surface. Working wet-on-dry results in distinct shapes and sharp edges.

Index

Credits

Paul Cézanne, *Still Life with Chair, Bottles, Apples* (page 7): from *Cézanne's Watercolors* by Götz Adriani, DuMont Buchverlag, Cologne.

Albrecht Dürer, Study for Pope's Robe for *The Feast of the Rose Garlands* (page 6): Graphische Sammlung Albertina, Vienna.

Juan Gris, *Three Lamps* (page 6): Kunstmuseum Bern.

Edouard Manet, *Flower Piece with Laburnum and Irises* (page 7): Graphische Sammlung Albertina, Vienna.

Emil Nolde, *China Figurine and Amaryllis* (page 6): Sammlung der Nolde-Stiftung, Seebüll.

Watercolors—Still Life
Recommended Readings

Edin, Rose. *Watercolor Workshop/1.* How To Series. Laguna Hills, California: Walter Foster Publishing, 1989. #HT213. ISBN: 0-92961-23-2.

Light, Duane R. *Watercolor.* Artist's Library Series. Laguna Hills, California: Walter Foster Publishing, 1984. #AL02. ISBN: 0-92961-04-6.

Peterson, Kolan. *Watercolors Step-by-Step.* How To Series. Laguna Hills, California: Walter Foster Publishing, 1989. #HT205. ISBN: 0-92961-47-X.

Powell, William F. *Watercolor & Acrylic Painting Materials.* Artist's Library Series. Laguna Hills, California: Walter Foster Publishing, 1990. #AL18. ISBN: 1-56010-060-5.